Dear
Judy, my dear friend.
Hope you enjoy this
lovely book. Love
Julie

LOVE

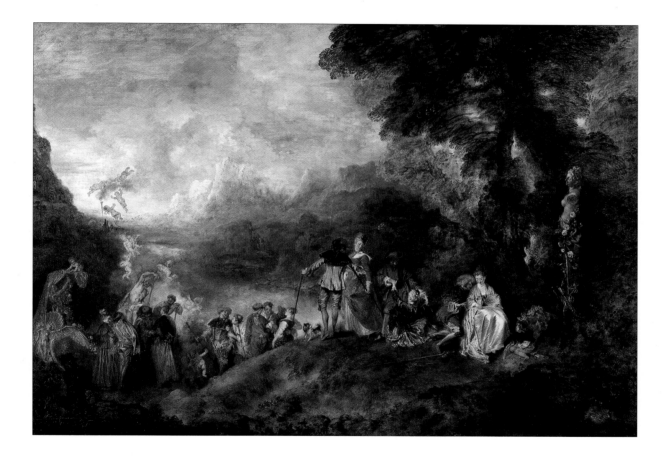

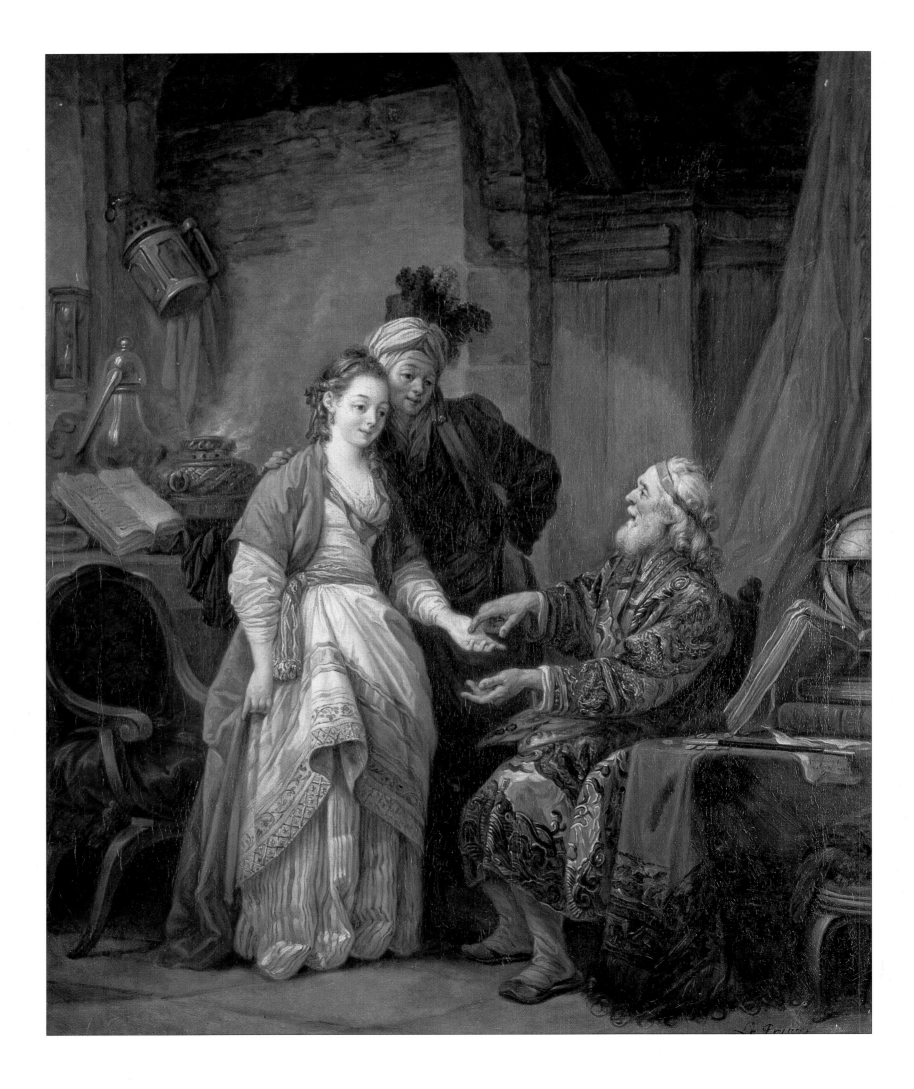

LOVE

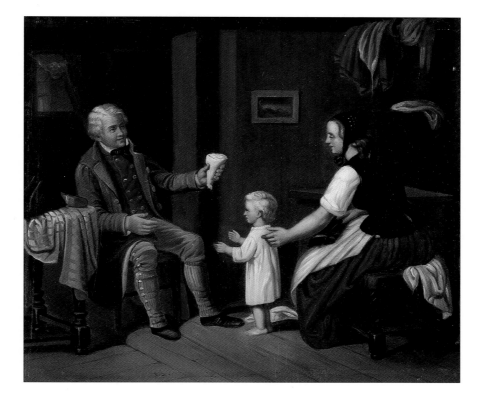

ALEXANDRA BONFANTE-WARREN

MetroBooks

MetroBooks

AN IMPRINT OF FRIEDMAN/FAIRFAX PUBLISHERS

© 1995 by Michael Friedman Publishing Group, Inc.

Library of Congress Cataloging-in-Publication Data
Bonfante-Warren, Alexandra.
 Love/Alexandra Bonfante-Warren.
 p. cm. — (Celebrations in art)
 Includes bibliographical references and index.
 ISBN 1-56799-167-X (hc)
 1. Love in art. 2. Art. I. Title. II. Series.
N8220.B66 1995
757'.6—dc20 95-8326
 CIP

Editor: Sharyn Rosart
Production Editor: Loretta Mowat
Art Director: Jeff Batzli
Designers: Lynne Yeamans and Lori Thorn
Photography Editor: Jennifer Crowe McMichael

Printed in China by Leefung-Asco Printers Ltd.

For bulk purchases and special sales, please contact:
Friedman/Fairfax Publishers
Attention: Sales Department
15 West 26th Street
New York, NY 10010
212/685-6610 FAX 212/685-1307

Additional Photography Credits: Page 1: Jean-Antoine Watteau, *A Pilgrimage to Cythera,* 1717. Oil on canvas, 51" × 76½" (129.5 × 194.3cm). Musée du Louvre, Paris. Giraudon/Art Resource, New York. Page 2: Jean-Baptiste Le Prince, *At the Palmist's,* c. 1775. Oil on canvas, 31" × 26" (78 × 66cm). The Hermitage, Saint Petersburg. Page 3: Unknown, *Interior Scene with Man, Woman, and Child,* nineteenth century. Oil on copper, 8½" × 10" (21 × 25.3cm). The University of Michigan Museum of Art. Gift of Miss Isabelle Stearns. Photo by Patrik Young. Page 5: Will Barnet, *Kiesler and Wife,* 1963–1965. Oil on canvas, 48" × 71½" (121.9 × 181.6cm). The Metropolitan Museum of Art, New York City. Purchase, Roy R. and Marie S. Neuberger Foundation, Inc. Gift of George A. Hearn Fund, 1966.

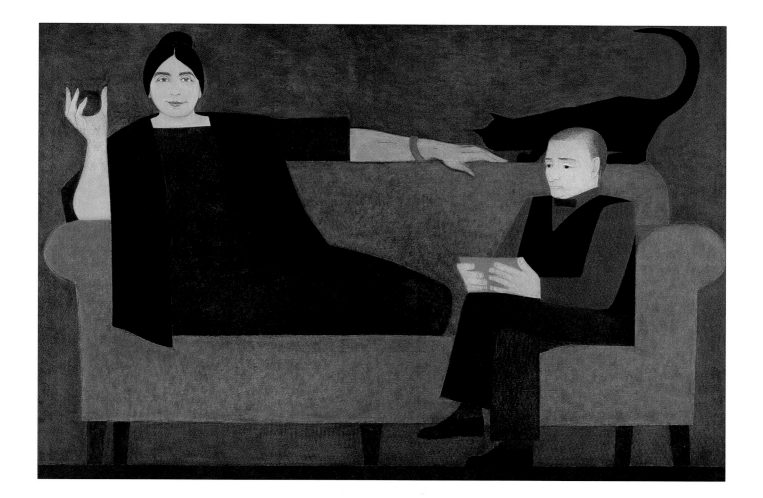

INTRODUCTION

In the history of human expression, one of the principal reasons we paint, write, or even just talk is to try to make sense

of the myriad mysteries that infuse our daily lives. Perhaps no enigma is more fascinating, powerful, exhilarating, bewil-

dering, sought after, or fled than love. Although there have been critics who have characterized love as destructive,

dangerous, or, at the very least, distracting to the smooth running of civilized society, there have been many more who

have described love as an exalted emotion, so profound and inspiring that it is synonymous with the creative force itself.

Indeed, this emotion, in all its parts, aspects, and consequences, has inspired the greatest works of all places and times.

Artists of every school have confronted the central problem: how can an artist depict something as singular—as

personal—as love?

One time-honored way is through myths. These tales convey the themes of human experience with room for the

extraordinary, the unaccountable, and the miraculous, all of these encompassing the painful uncertainty that arises from

our own unruly feelings, when we are faced with the sudden fact of an "other" so necessary to us. Jean-Léon Gérôme

added to the notion of a dream (girl) come true the artist's enmeshment with the work of art. But covert in *Pygmalion*

and Galatea (c. 1890) is the wish to avoid the mess by staying within one's imagination. On the other hand, for his sophis-

ticated, aristocratic audience, Peter Paul Rubens had already demoted Eros, son of the splendid, revered Greek goddess

Aphrodite, to a chubby, mischievous little cherub, the master of ceremonies in *The Garden of Love* (c. 1638).

Desired and feared, the "tender passion" at its onset is all uncertainty. In *At the Palmist's* (c. 1775), Jean-Baptiste Le

Prince depicted a young couple resorting, as people always have and will, to one who can see through or past the cloudy

or obstructed present to the sweethearts' future. Artists themselves may build enigmas into their pictures for us to read,

to say what proper speech ought not: Nicolas Lancret coyly does this in his painting *Spring* (1738).

The artist may make a metaphor even more explicit—or simply allow the image to resonate. The journey of life,

a trip over the uncharted seas, has been a constant motif in art describing true, mature love. In *On a Sailing Ship*

(1818–1819), we observe Caspar David Friedrich and his bride from behind, heading into the fair harbor on a yacht;

the grim faces of the bewildered voyagers in *The Last of England* (1852–1855) by Ford Madox Brown remind us of the

hard choices couples have faced together over the centuries.

How does the artist convey the breathlessness we feel at the nearness of a beloved, the ecstasy of surrender, or the

joy and relief of knowing we are loved in return? The images by Marc Chagall and Gustav Klimt show how technique

and content become as inseparable as any couple. Chagall's visual dance in *Birthday* (1915) embraces an array of styles to convey the lighthearted yet profound joy elicited by his betrothal. Klimt, in the sumptuous and hieratic gold and brilliant colors of his "decadence," suggests the pagan, irresistible impulse of desire in *The Kiss* (1907–1908). At the same time, his painting goes further, seeking to convey the transcendent realm where the erotic and the spiritual become one—a blurring depicted from the other side by religious artists as well. It is an experience we acknowledge when we speak of "adoring" our dearest; in today's vocabulary, idolatry becomes obsession. Few have depicted this component of love with more lucid irony than Frida Kahlo in *Self-Portrait with Diego on My Mind* (1943)—or with tongue more firmly in cheek than Roy Lichtenstein in *Drowning Girl* (1963).

Also in the mix is another face of surrender: the serene and sober acceptance of the wonderful, inexplicable fact of reciprocated love, a moment captured by Fra Filippo Lippi, who delicately limns the intimacy that accompanies that instant in *Portrait of a Man and a Woman at a Casement* (c. 1440). In *The Marriage of Giovanni Arnolfini and Giovanna Cenami* (1434), Jan van Eyck witnessed the wedding that celebrates that blending of the sacred and the human. The marriage that follows will be as individual as the two unique people who define it. Lorenzo Lotto showed one such marriage in *Husband and Wife* (c. 1543): an intense, but surely not always easy, union of two persons—one that contains feeling and

depth. Jacques-Louis David depicted *Antoine-Laurent Lavoisier and His Wife* (1788) as an alliance typical of his time: fond,

reasonable, and sunny. Oskar Kokoschka illustrated the electric, sensual passion of the intellect shared by *Hans Tietze*

and Erica Tietze-Conrat (1909), while Will Barnet affectionately implies the mystery at the heart of every union that no

outsider can know in *Kiesler and Wife* (1963–1965).

When he painted *The Visit to the Lying-in Chamber* (1661), Gabriel Metsu deftly used chiaroscuro, or light and shad-

ow, to portray an image of the public side of love's private state. Safely delivered of a child, a new mother, flanked by

her husband, receives the couple's friend. It is clear that from this moment, the lovers' lives will change utterly once

more as a union of two becomes a family. The nineteenth-century *Interior Scene with Man, Woman, and Child* is a picture of

the sufficiency of a contented family by itself in a cozy home, where joy, more than material blessings, is the abundance

they share. The sweetness of daily life together, epitomized by the sleepy comfort of early morning routine in *Allegheny*

Morning Sky (1978), is conveyed by Romare Bearden in his picture of caring for another: the woman has risen even

earlier than her husband to give him breakfast before he heads off to the factory. Similarly, Palmer Hayden shows the

loving family of *The Janitor Who Paints* (1939–1940)—including the cat—supporting one member's dream in a unity of

companionship that gives humble and glowing meaning to the promise: for better or for worse.

Jan van Eyck

The Marriage of Giovanni Arnolfini and Giovanna Cenami

1434

Oil on canvas, 33" × 22½" (82.5 × 56.2cm). National Gallery, London.

Jan van Eyck (before 1395–1441), along with his contemporary Robert Campin (c. 1378–1444), is admired for the highly finished realism he constructed out of light and texture. At that time, Flanders was an active center of trade, and Italian merchants were central to the commercial life. Giovanni Arnolfini and Giovanna Cenami were from two such families. That they are wealthy is evident from their opulent and fashionable clothing: Giovanni's houppelande is gathered in organ pleats at the shoulder, while Giovanna, elegant in the ladylike "Gothic slouch," further emphasizes the line of her body with the fabric she holds up at her waist, revealing the costly cloth of her underskirt. But van Eyck was equally renowned for the fervently religious content of his work, evident in this painting, which probably served as a marriage certificate—the artist, reflected in the mirror on the back wall, was one of two witnesses. The dog is commonly a symbol of marital fidelity, and the wood pattens, or clogs, may signify that the new household is "holy ground." Above the mirror is a Latin phrase that means "Jan van Eyck was here"; around the frame of the mirror are scenes of Christ's passion, reminding the viewer that the Roman Catholic couple wished it to be recorded that their marriage was well and truly a sacrament.

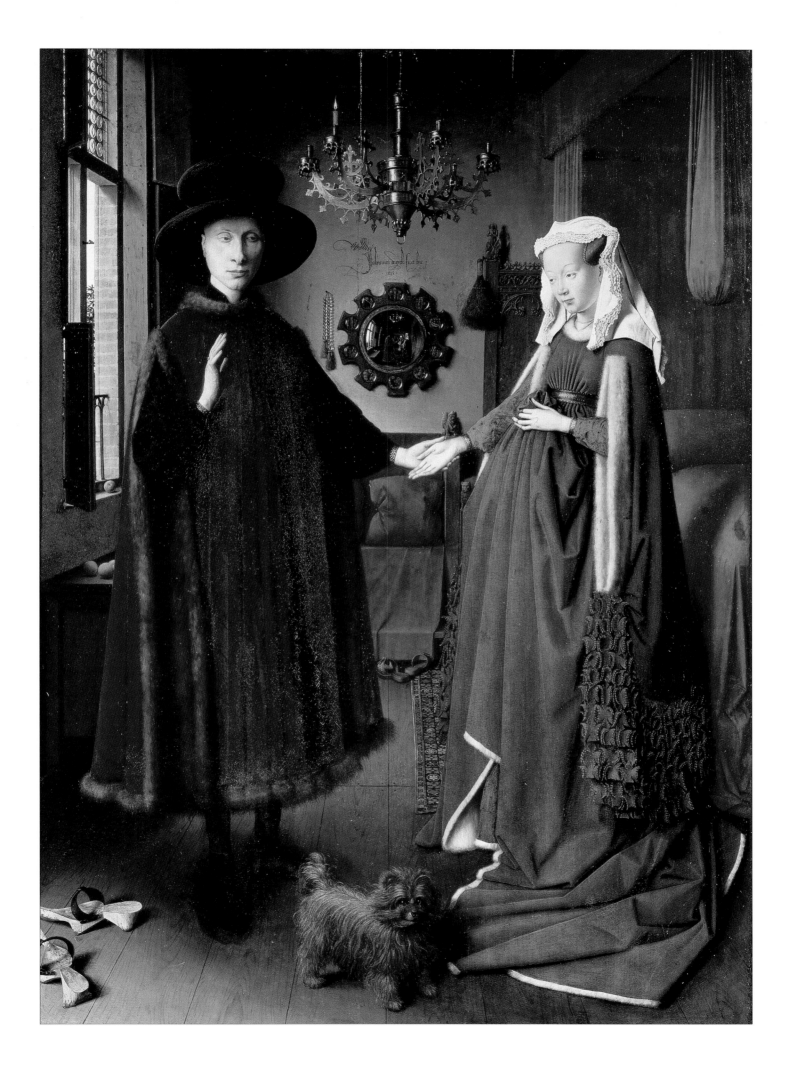

FRA FILIPPO LIPPI

Portrait of a Man and a Woman at a Casement

c. 1440

TEMPERA ON WOOD, 25¼" × 16½" (64.1 × 41.9CM). THE METROPOLITAN MUSEUM OF ART, NEW YORK CITY.

*P*ope Pius II released Fra Filippo Lippi (c. 1406–1469) from his vows around 1461, after forty years in the mendicant order of the Carmelites. Nevertheless, the artist's monastic title has endured, just as his religious experience endures in this secular portrayal of courtship. A sheltered young lady of the aristocracy might well be wooed through a window, much as the bolder Juliet received Romeo's speech from a balcony. There is a conflict, however, between the artist's need to place the lady (in a villa in Florence by—or, mysteriously, over—the River Arno) and the plausibility of a suitor suspended in midair. The organization by importance of element rather than by "realistic" composition is a carryover from medieval pictorial conventions. Despite its title, this painting could easily be a secularized "Annunciation," so closely does it correspond, though in close-up, to traditional depictions of that New Testament episode—perhaps the visual reference to sexual relations most familiar to the Carmelite brother.

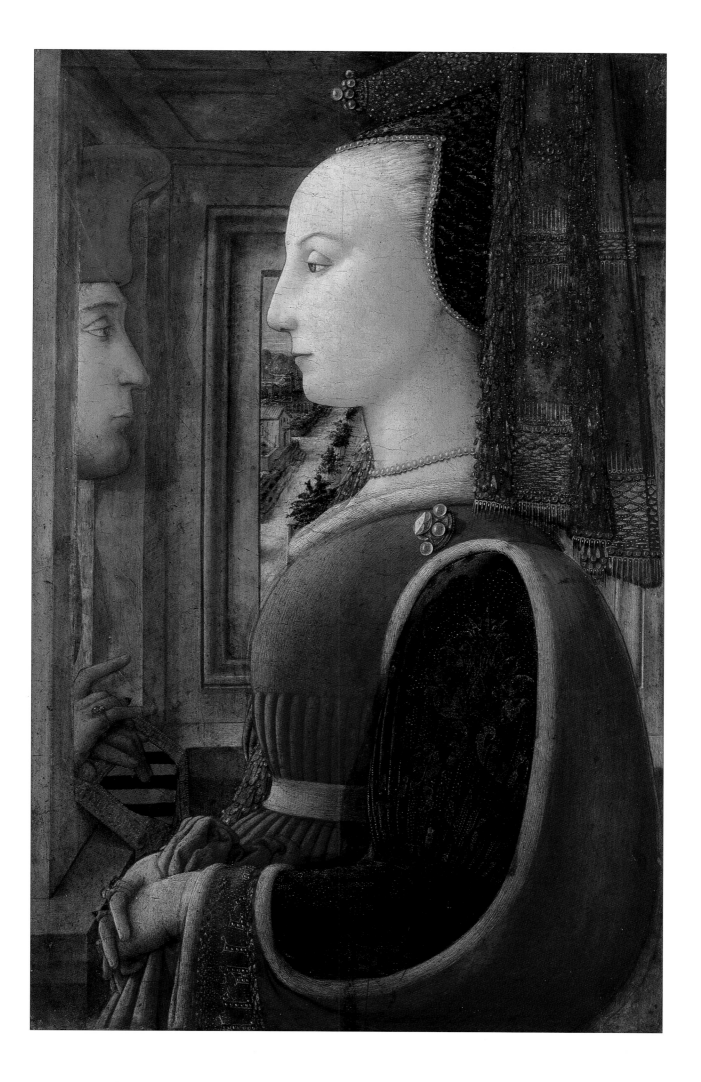

LORENZO LOTTO

Husband and Wife

c. 1543

OIL ON CANVAS, 38" × 45½" (96 × 116CM). THE HERMITAGE, SAINT PETERSBURG.

There is a legend that Lorenzo Lotto (c. 1480–1556) painted the only contemporary portrait of Christopher Columbus. The artist is principally known for his mystical treatment of religious subjects, so it is not surprising that he brought an insight startling in its complex wisdom to the numerous portraits he executed. Here, the man and woman seem to lean toward each other and touch almost in spite of themselves. They are strong, distinct personalities, and should a viewer need a further clue, the artist painted a storm-tossed landscape in the upper left corner. Other clues are in the pets—though in the presence of such intense souls, the animals appear more like witches' familiars. The wife's dog may represent faithfulness, but it is cute and frisky, as specific a portrait as that of its masters. The monkey, an emblem of lust, sleeps for now, but lest we miss it, the husband points with a beringed finger. In his left hand, he holds a sheet of paper he has unfolded for the occasion. It says *Homo Nunquam*: "Human beings never…." We can only guess.

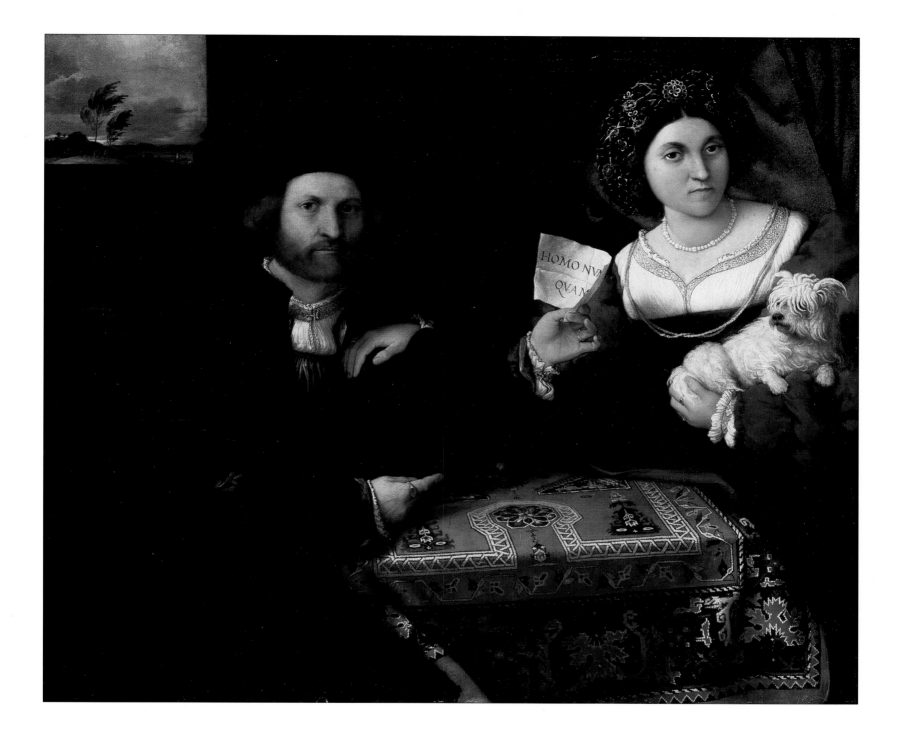

Joachim Beuckelaer

A Village Celebration

1563

Oil on canvas, transferred from panel, 44" × 64" (112 × 163.5cm). The Hermitage, Saint Petersburg.

During the sixteenth century, for the people of the Low Countries, kermises, or outdoor festivals, marked the high points of the calendar, religious, agricultural, or both. Often, the lords and ladies of the manor joined the peasants in their simple celebrations—pleasures still heartfelt for the landowners, who benefited from an abundant harvest as much as, or even more than, their tenants. The nobles that dance at this village celebration are prominent, not only placed in the foreground but also portrayed in greater detail. Was this emphasis on the nobility, perhaps, a way for Beuckelaer (c.1533–1573/74) to distance himself from the poverty of his past? The formal dance takes on additional meanings against the rowdy, diverse pastimes of the peasantry. In the context of any holiday or holy day, the dance, with its measures and repeated patterns, recalls the cycles of seasons and time. In courtship, the dance signifies the back and forth of attraction, the testing of the mute and mysterious lure of inclination. In the context of *A Village Celebration*, it also represents the triumph of the orderly over the disorderly, the reason why the divine master of ceremonies was believed to have set some people above others. This scene shows a decorous kind of love, one that follows the proper steps and rhythms, repeating the timeless, age-old design.

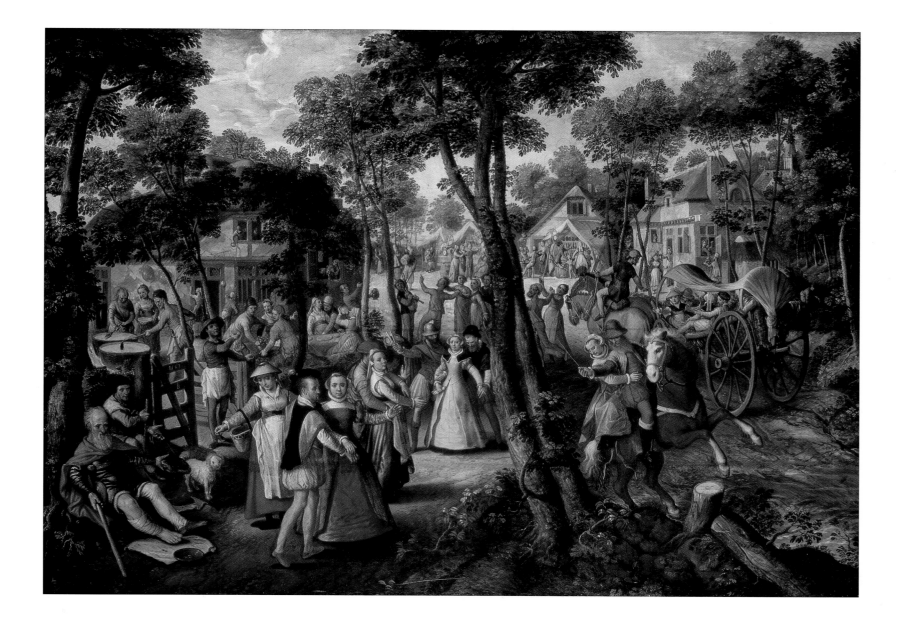

Reza-ye 'Abbasi*

Courtly Lovers

1630

TEMPERA AND GILT ON PAPER, 7⅛" × 4¹¹⁄₁₆" (17.8 × 11.7CM). THE METROPOLITAN MUSEUM OF ART, NEW YORK CITY.

The Persian artists of the Timurid (c. 1409–1501) and later the Savafid (1501–1732) dynasties were renowned for their exquisite miniatures and other works. The paintings of the seventeenth century are among the most elegantly voluptuous in the history of art, dedicated to conveying the happy sensuality of love. For these artists, a successful work was one that rendered a mood, as the elements of this painting combine to create an atmosphere of refined sensuality. The artist has used rich, warm colors—note the brown on gold of the young woman embraced by her beloved, who wears a jewel-green tunic. Rather than detail facial expression, this artist relied on gesture, as well as on the subtle, metaphorical transference from one element to another, to convey meaning. For example, the woman holds a fruit in her left hand, suggesting that she is savoring her lover's touch. The exquisite delicacy of colors and lines is in keeping with the subject matter, for, as in European culture, the well-born were believed to be more refined. Indeed, the half-full jug of wine tells us of the couple's moderation even in their amorous intoxication. Around them, all nature seems to conspire in rhythmic beauty.

* Painted in the royal studio founded by Shah Abbas I, signed by Reza-ye 'Abbasi, chief court painter.

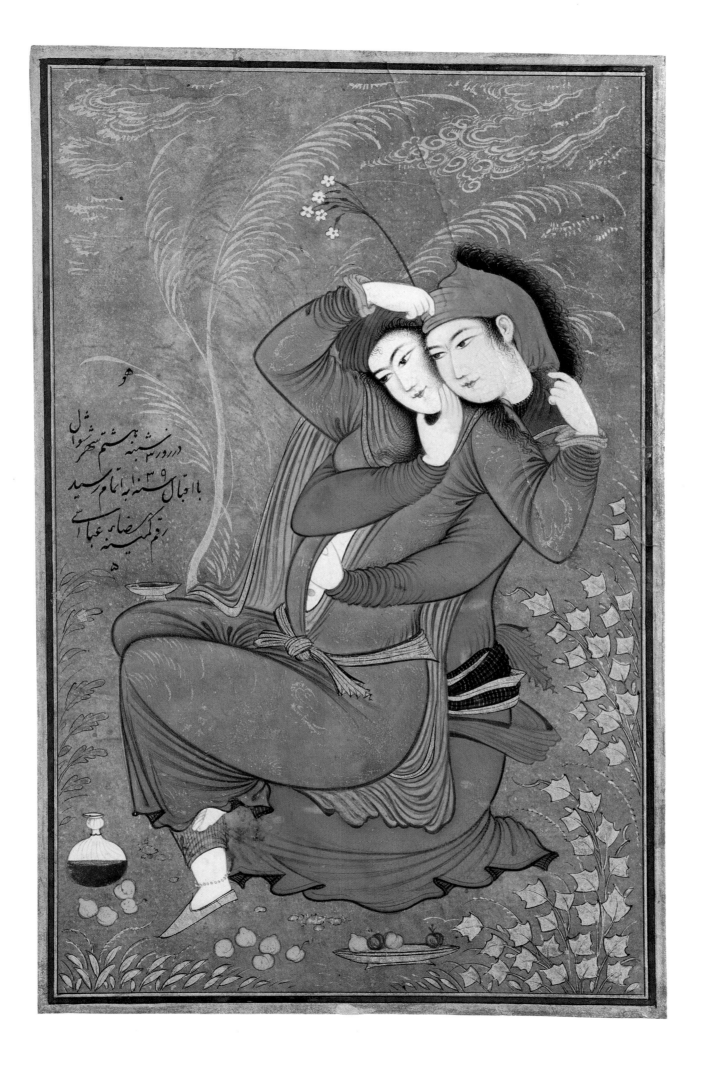

Nicolas Poussin

Cephalus and Aurora

c. 1630

Oil on canvas, 38" × 51" (96.7 × 129.5cm). National Gallery, London.

One of the most important French artists of his century, Nicolas Poussin (1596–1665) worked principally in Rome,

where he drew inspiration for the classical paintings for which he was famous. His subjects were most often biblical or

mythological; one example is *Cephalus and Aurora*. Aurora, the Greek goddess of the dawn, fell in love with Cephalus and

carried him off, but Cephalus loved his wife, Procris, so deeply that he would not forsake her even for the embrace of

a deity. The story does not end there, but moves through felicity, tragedy, and irony to illuminate human nature and the

vagaries of happenstance. Poussin, however, chose to depict a moment celebrating the power of virtue. The artist's

audience shared a uniform education and therefore a body of references that allowed them to "read" works with such

allusions. It may be, too, that the appeal of the ancient myths was—and still is—that they admit a larger reality than the

rational mind can encompass even as they portray the timeless ways of the human heart.

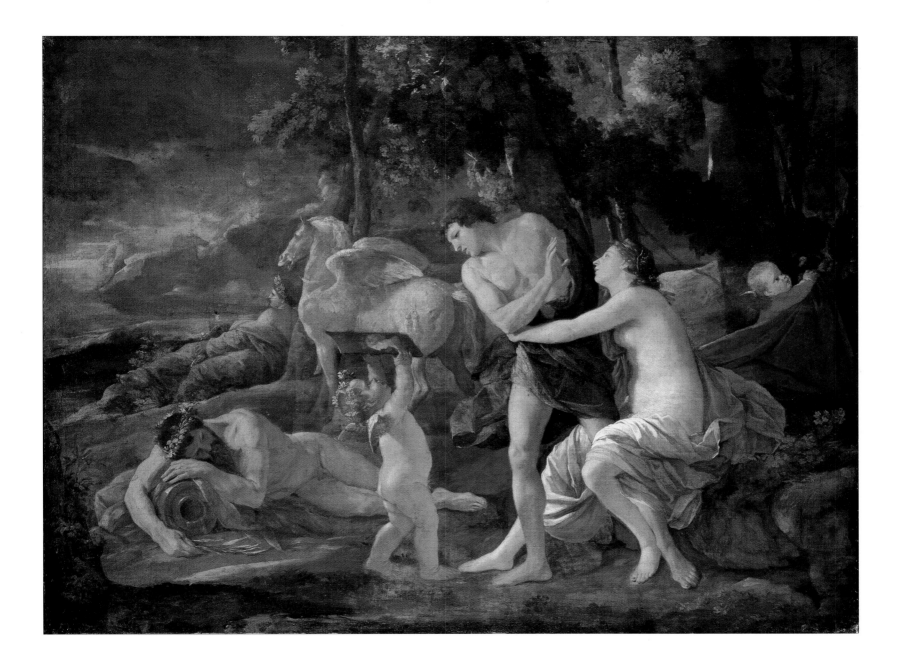

Rembrandt

Saskia as Flora

1635

Oil on canvas, 49" × 40" (125 × 101cm). The Hermitage, Saint Petersburg.

In 1631, Rembrandt (1606–1669) settled in Amsterdam. He would prove to be a prolific artist, producing paintings, etchings, prints, and drawings—over sixteen hundred drawings survive. His subjects included biblical and mythical stories, landscapes, still lifes, genre pictures, and many self-portraits, as well as portraits of himself and his wife, Saskia van Uylenburgh, a young woman from a prosperous family, whom he married in 1634. Rembrandt lovingly painted abundance into every aspect of this portrait, from the lavish fabrics of Saskia's gown in elegant hues derived from nature, to her discreetly announced pregnancy, to the sweet, interior joy of her expression. Flower patterns seem to force themselves out of the mysterious dimness around Rembrandt's beloved, emphasizing the mastery of light and shadow for which the portrait painter and teacher was already well known. The reference to Flora, the Roman goddess of flowers, gives a conventionally classical overlay to an intensely personal visual celebration. Rembrandt was to lose Saskia in the aftermath of the birth of their son Titus in 1642; in subsequent works the painterly exuberance that characterizes *Saskia as Flora* became transformed into intimate, specific depictions of life's goodness.

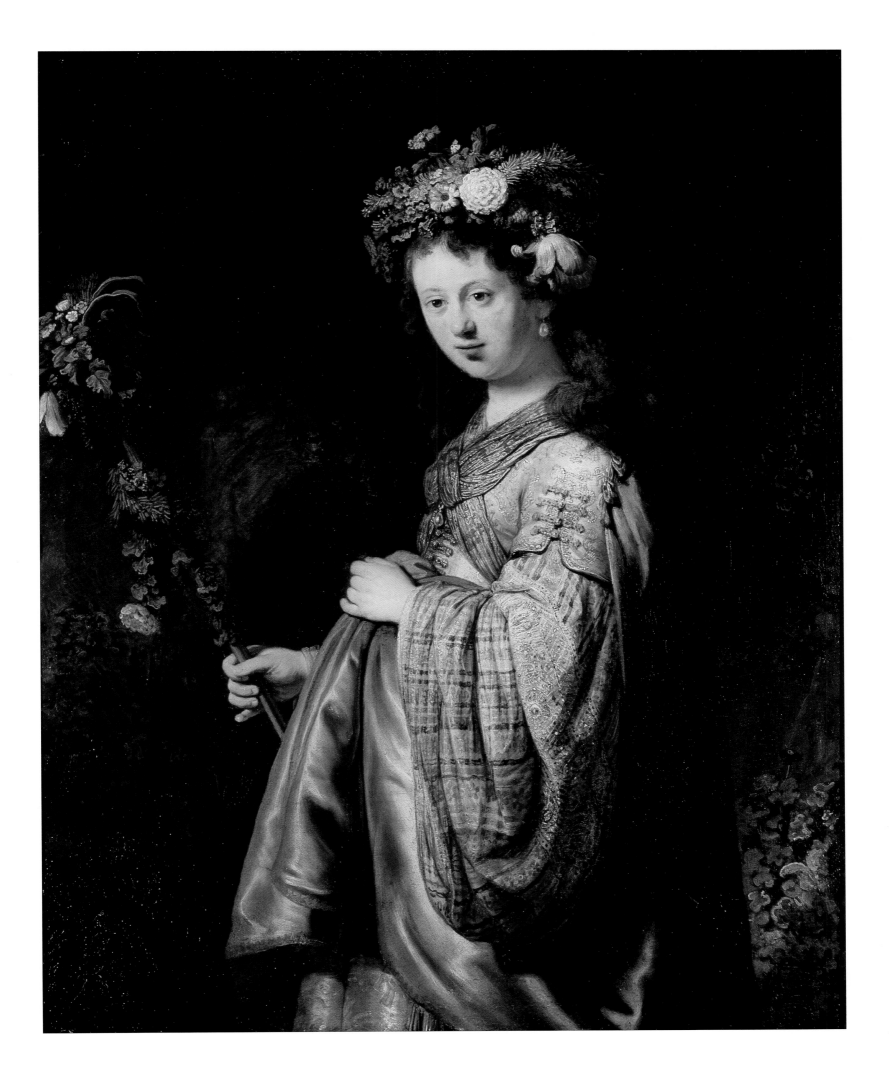

PETER PAUL RUBENS

The Garden of Love

c. 1638

OIL ON CANVAS, 78" × 111½" (198.1 × 283.2CM). MUSEO DEL PRADO, MADRID.

Even the trees are dimpled in this example of Baroque excess by Rubens (1577–1640), where the "garden" of the title resembles the park of a country manor. Eros reigns—in fact, he is literally pushing the couple in the foreground, impatient with the wooer's delicate toying with a bow on his lady's sleeve. The pouty, tousled little angel is one of two figures who look directly at the viewer; the other is the complaisant maiden whose clear-eyed gaze meets ours, the near-boredom in her expression perhaps Rubens' hint of what lies beyond satiety. This may be one of the wistful meanings of the metaphor of the garden of love: a spot outside time and space, beyond cause and effect, where infatuation may run its course with no consequences, a full circle from and to the innocence of Eden. Rubens knew the worldly life very well: he was in the service of the Gonzaga ducal court in Mantua, decorated the Luxembourg for Marie de Médicis in Paris, and traveled to Madrid and London as a diplomat for the Habsburgs.

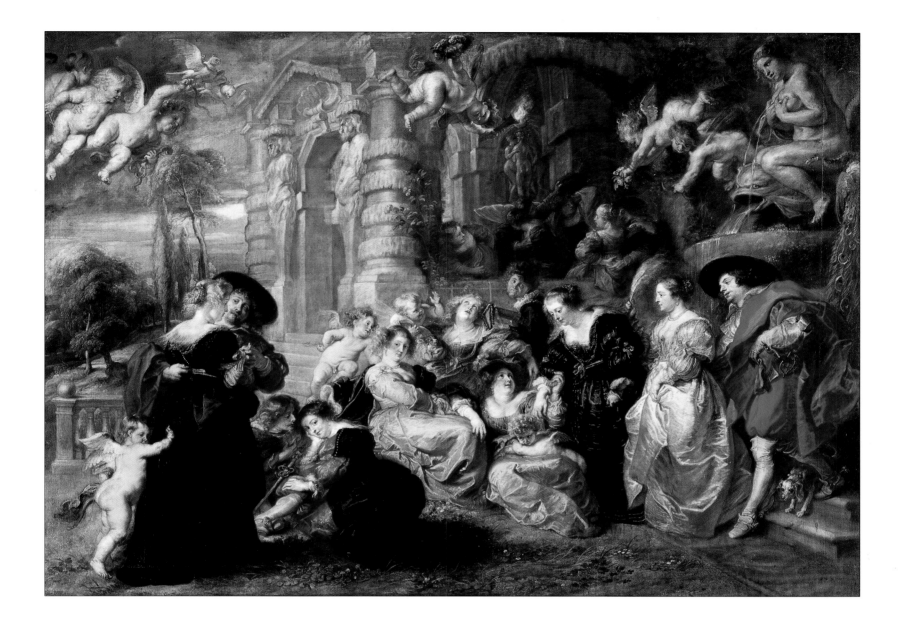

GABRIEL METSU

The Visit to the Lying-in Chamber

1661

OIL ON CANVAS, 30½" × 32" (77.5 × 81.3CM). THE METROPOLITAN MUSEUM OF ART, NEW YORK CITY.

Gabriel Metsu (1629–1667) is best known for the skill and warmth he brought to scenes of everyday life, the "tender mercies" that genre painting celebrates. As in a still life, what we see is what we get—and what we get is the opportunity to contemplate activities we are often in the midst of. In *The Visit to the Lying-in Chamber*, Metsu has subordinated the more private moment to the more social one, thereby allowing us to fill in some of the emotional content. A friend or relation comes to see a new mother; a servant brings her a chair and a warming-box for her feet. In an age when childbirth was both taken for granted and often fatal, the combination of joy and relief the visitor feels is evident in her posture and reflected in the new father's welcoming bow. All in white satin, the seated woman is the star of the event, as of the picture; she holds her swaddled infant beneath a half-exposed breast that defines her new identity. Wife, husband, and child; mother or midwife; friend; servant: in his depiction of a single moment, Metsu has encompassed the expanding circles of domestic love.

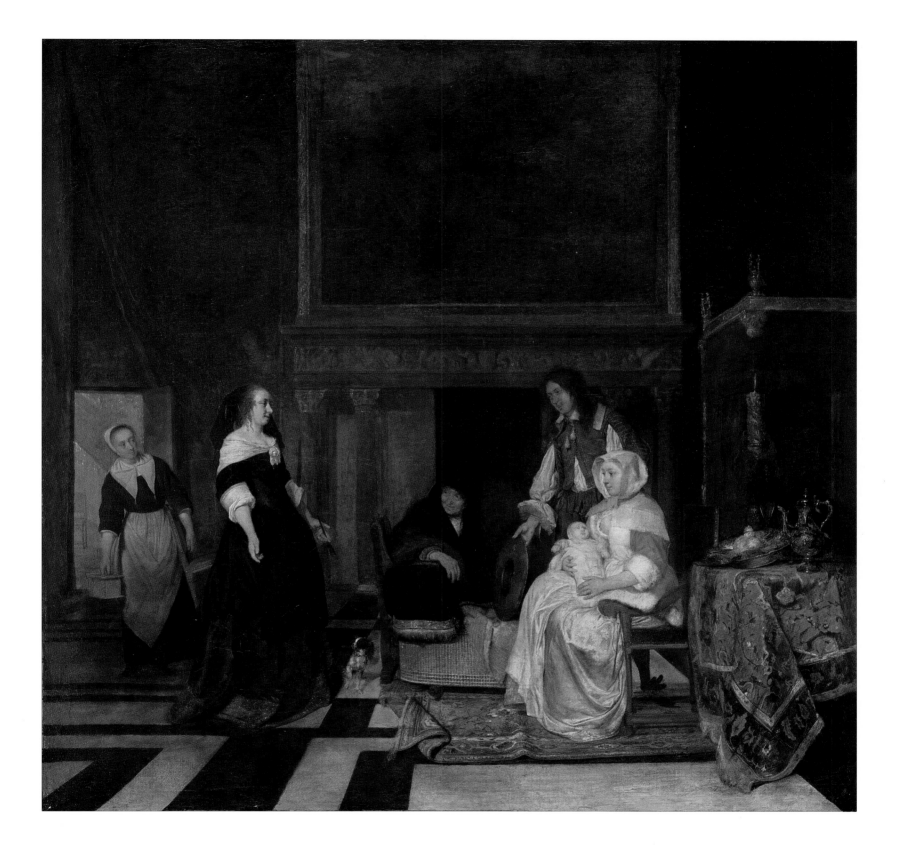

HISHIKAWA MORONOBU

The Lovers

1683

WOODBLOCK PRINT, SUMI-E, FROM A SET OF TWELVE SHEETS, 11½" × 13½" (29.2 × 34.2CM).
THE METROPOLITAN MUSEUM OF ART, NEW YORK CITY.

Hishikawa Moronobu (c. 1625–1694), a painter and printmaker, son of an embroiderer and designer of textile patterns, was one of the initiators of ukiyo-e, "pictures of the floating world," a Japanese art movement that flourished from the seventeenth to nineteenth centuries. The amorous gentleman is a samurai, whose sword is prominently placed in the composition. The lady may be a courtesan, attired in layers of kimonos—the luxurious fabrics serving to conceal her wooer's venturesome touch. She is demure, face half-hidden by a fold of her clothing, eyes closed, like his, in pure concentration on the beloved's presence. The lithe lines of the lovers are as fluid as those of the natural forms in the upper right corner, while a profusion of flowers springs from the flat plane of the ground to the left—perhaps perfuming the air the tender couple breathes, or expressing their pleasure.

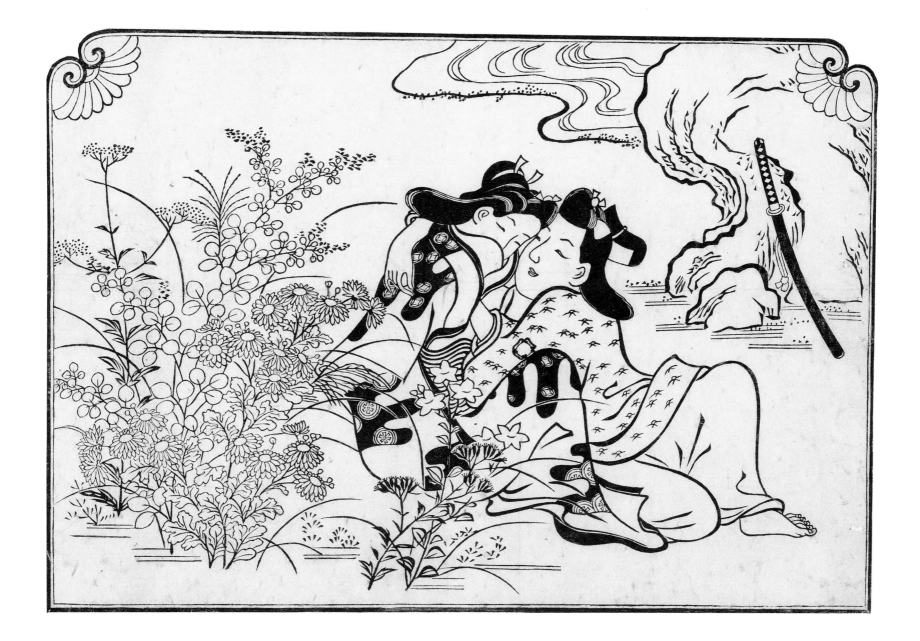

PIETER GYSELS

Garden

Date Unknown

OIL ON COPPER, 20½" × 25½" (52.5 × 64.5CM). THE HERMITAGE, SAINT PETERSBURG.

In this garden scene, the succulent cascade of abundance testifies to the wealth of the landowner and to the good management that could produce such a lavish diversity. When we look more closely, we see signs of what Colin Eisler calls in his book *Paintings in the Hermitage* "the lord of the manor's cosmic domain"—for example, the monkey and the parrot, denizens of foreign climes, and the Oriental carpet. The sensual references are bold—the contrast between these and the sketchily painted human figures is almost shocking. Pieter Gysels (1621–1690/91), known for his still-life scenes as well as his landscapes and genre paintings, may simply have wished to focus the composition by downplaying other elements, or he may have intended a statement that the individual members of the lineage were less important than the continuation of the family and its power. In either case, there is a frank echo of the peacock's tail in the train of the woman in the corner of the garden. Besides the two human couples, there are a number of animal pairs, all testifying to a grand fertility—like a divine blessing on an aristocratic Eden.

Nicolas Lancret

Spring

1738

Oil on canvas, 45½" × 37½" (115.5 × 95cm). The Hermitage, Saint Petersburg.

Nicolas Lancret (1690–1743) was a decorator as well as a painter: *Spring* is one of four paintings he did for a series, *The Seasons*, commissioned for the chateau of La Muette. In this fictive season, everyone's fancy seems lightly to be turning to everyone else's fancy, and virtue is conspicuous by its absence. Here is love as entertainment, corruption and innocence merging in a depiction of romance as playfully promiscuous. The subject is both frankly and implicity sexual: the young woman in the center is blushing becomingly, yet her posture is careless, even wanton; the physical familiarity between her and her sweetheart bespeaks an intimate knowledge. Emblems are encoded into the picture: a bird on a string may stand for the feelings of the woman on the right, whose jealousy ties her to the scene. The open cage on which the center maiden rests her hand tells us delicately that she has lost her virginity. This kind of laxness in the silk- and satin-clad class, however, was generally reserved for married folk, since their sophisticated and clear-eyed society made a distinction between legal alliances, formed for dynastic reasons, and *affaires du coeur.*

François Boucher

Pastoral Scene

1746 or 1755

OIL ON CANVAS, 24" × 29½" (61 × 75CM). THE HERMITAGE, SAINT PETERSBURG.

François Boucher (1703–1770) was Director of the French Royal Academy; a favorite of Madame de Pompadour, Louis XV's official mistress; and chief painter at the court. Madame de Pompadour was a patron of writers, artists, and artisans, so Boucher also devised compositions for Beauvais tapestries and Gobelins porcelains. The soft, bright colors in *Pastoral Scene* are characteristic of this master of French Rococo, as is the lighthearted depiction of love as an eternal, intoxicating moment with no consequences, only endless felicity and fidelity—this last represented by the dog at the shepherdess' feet. These tousled, silk-clad Arcadians feed on wine and the luscious fruit of timeless summer, the season of consummated desire. Yet their innocent passion is poignant, reflecting perhaps, like so many novels of the time, the longing of a sophisticated, even cynical, society for a simpler, more natural time—which may have existed only in the imaginations of well-read, well-bred ladies and gentlemen.

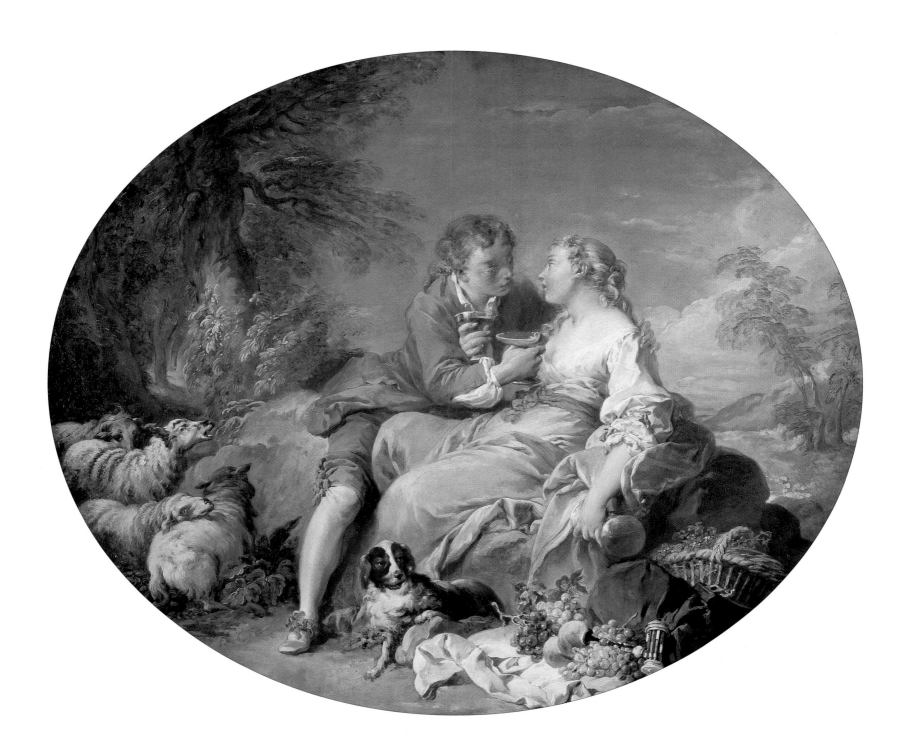

JEAN-HONORÉ FRAGONARD

The Stolen Kiss

c. 1761–1765

OIL ON CANVAS, 16" × 21½" (45 × 55CM). THE HERMITAGE, SAINT PETERSBURG.

Jean-Honoré Fragonard (1732–1806) was an artist and etcher who studied under Jean-Baptiste-Siméon Chardin and François Boucher. Over the course of his successful career, Fragonard changed techniques and styles—from informal, almost sketchlike brush strokes to the elaborate coquetries of Rococo to the relative sobriety of Neoclassicism.

Though the Enlightenment thinkers questioned even the most accepted premises of Western thought, relations between the sexes still followed the dictates of ancient assumptions. The most basic of these was that a woman's love must be won, indeed conquered: a "natural," or good, woman might inspire desire, but did not experience it herself. Fragonard's depiction of traditional relations purports to be innocent, due to the youth of the two figures, but ambiguities appear as soon as one looks more closely. The composition balances the young woman and her transparent shawl, a flirtatious article of clothing that may also act as a visual double entendre referring to her "virtue", an interpretation reinforced by the awkward device of the young man forcing his way through the door. This world of coy ribaldry was about to end: the French Revolution would sweep away many of Fragonard's clientele, virtually ending his artistic career.

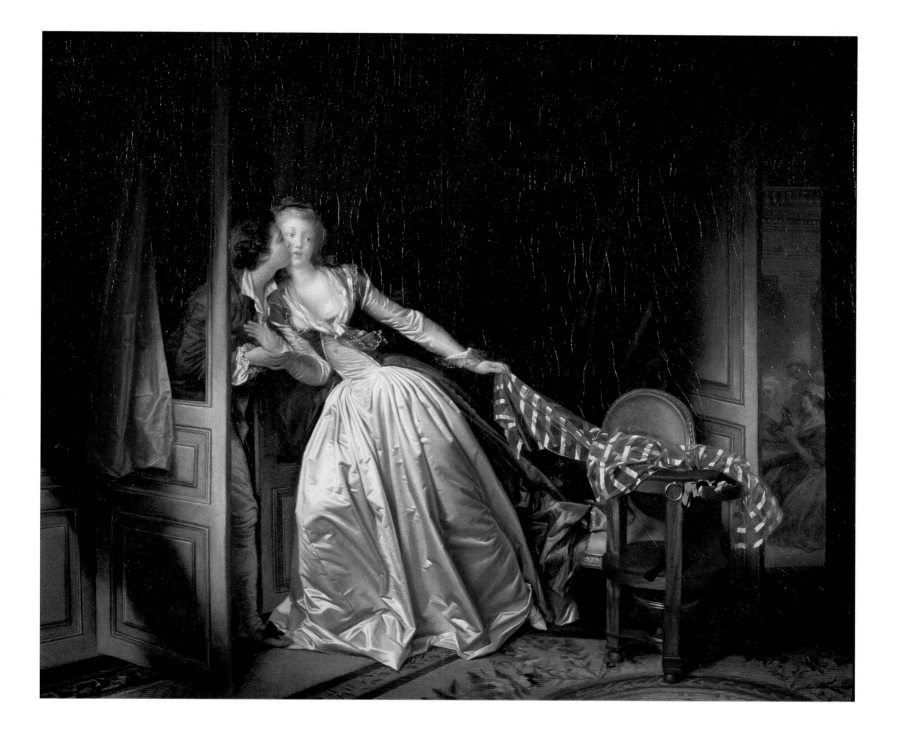

Jacques-Louis David

Antoine-Laurent Lavoisier and His Wife

1788

Oil on canvas, 102¼" × 76⅝" (259.7 × 194.6cm). The Metropolitan Museum of Art, New York City.

Known as the father of modern chemistry, Antoine-Laurent Lavoisier (1743–1794), working alone and with others such as Pierre-Simon de Laplace, revolutionized science in his time. He also served as a member of the national commission to establish uniform weights and measures—as illustrated by the metal weights strewn at Lavoisier's shapely foot. Lavoisier was deeply in love with his wife, Marie-Anne Pierrette Paulze, and evidently proud of his feeling for her, choosing to be portrayed gazing at her in admiration, as writers and other artists were depicted looking to their muses. David (1748–1825) was one of the innovators of the Neoclassical style—here represented by the pilasters that decorate the wall behind the affectionate couple. The artist was also close to Robespierre and a member of the National Convention, surviving the Revolution to abolish the Académie Royale, then later to become court painter under Napoléon I. Lavoisier was less fortunate: in 1794 he was arrested by order of the Convention and guillotined. His widow was to live another forty-two years.

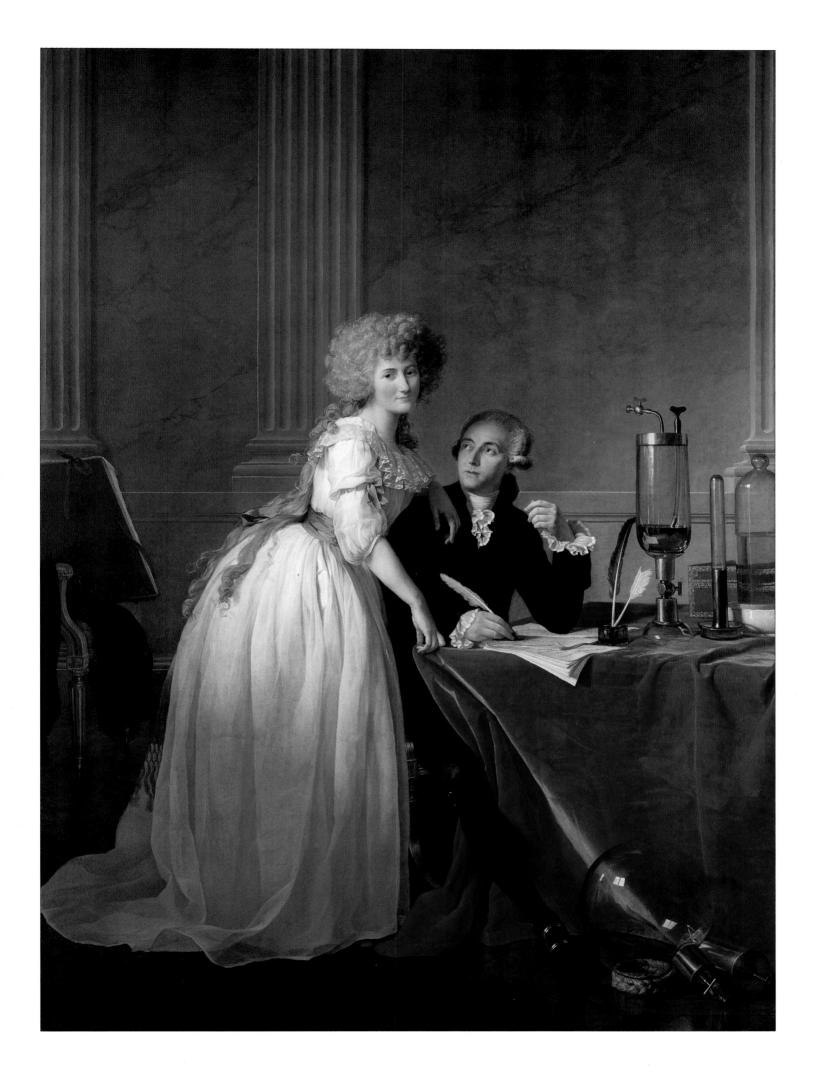

MARGUÉRITE GÉRARD

Prelude to a Concert

c. 1810

OIL ON CANVAS, 22¼" × 18¾" (56.5 × 47.6CM). THE NATIONAL MUSEUM OF WOMEN IN THE ARTS, WASHINGTON, D.C.

Marguérite Gérard (1761–1837) was Jean-Honoré Fragonard's sister-in-law; not only did she learn from her acclaimed relative by marriage, but she met other successful artists and was able to visit private collections. Gérard showed her paintings at the Paris Salons from the 1790s, when women's work was first admitted, until she retired in 1824. She received three medals, and sold to Louis XVIII and to Napoléon I, among others. A popular artist, Gérard adopted the realistic, anecdotal genre style of a century before, which appealed to the upper middle classes in post-Revolutionary France. In this work, she has applied a dramatic chiaroscuro technique to an intensely romantic, ambiguous composition. The young woman appears to be bathed in heavenly light (while, in the best painterly tradition, the satin fabric displays the artist's virtuosity). But is she rapturously anticipating a breathless moment of love—a passionate concert—or remembering with longing a lost *grand amour?*

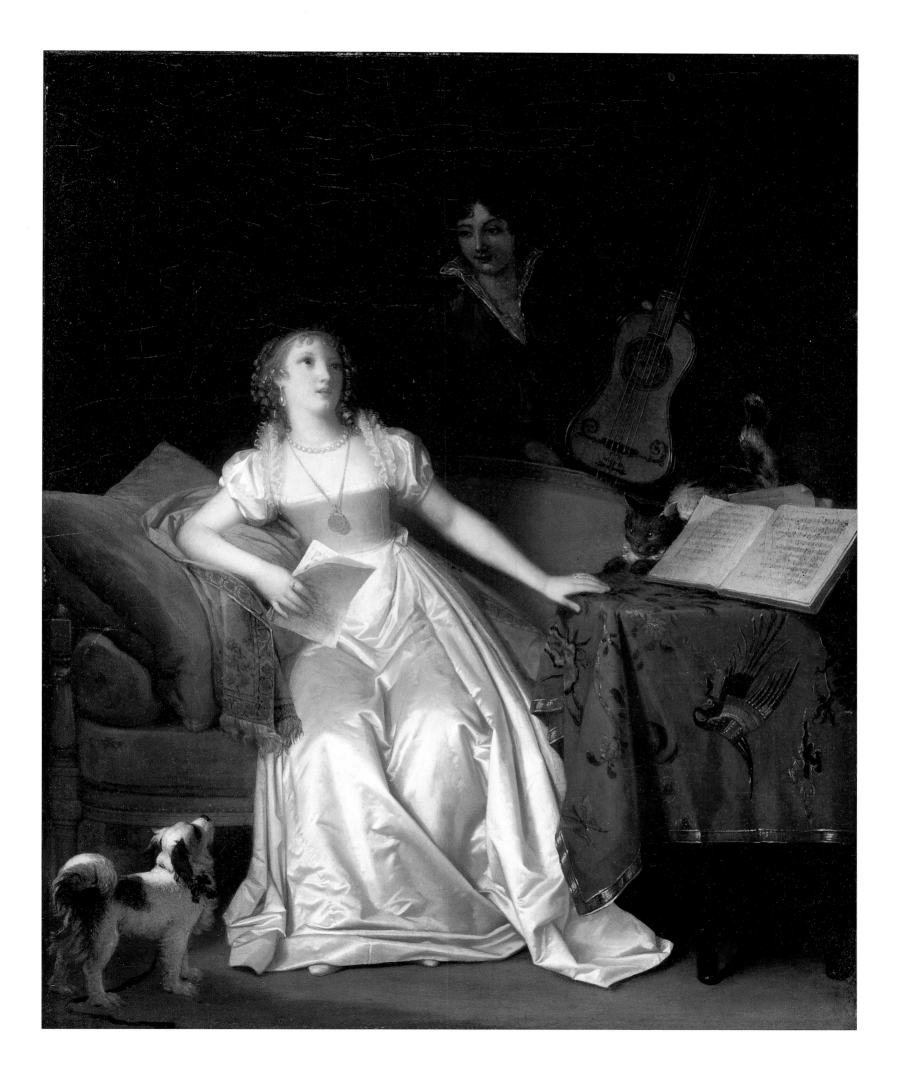

CASPAR DAVID FRIEDRICH

On a Sailing Ship

1818–1819

OIL ON CANVAS, 28" × 22" (71 × 56CM). THE HERMITAGE, SAINT PETERSBURG.

The couple holding hands, gazing into a luminous future, are the artist and his wife on their honeymoon. Friedrich (1774–1840) was essentially self-taught, and principally painted scenes derived from the natural world, whether land or sea. The Dresden-based painter often imbued his works with feelings of desolation—the sentiment that inspired much of the emotional content and power of German Romanticism. This picture, however, is in a more intimate vein, bordering on the metaphorical, with a transcendent glow that dominates the whole. The vast, brilliant sky, resembling those of Friedrich's contemporary Joseph Mallord William Turner (1775–1851); the ship headed into port; the sails filled with wind; the grace of shared silence—these elements come together in a composition that expresses the figures' inner emotions. But there is a more modestly romantic quality, too. The couple are literally facing life together as they begin their marriage; there is an affectionate physical connection, but theirs is not the *folie à deux* of transitory passion. In 1820, Friedrich sold *On a Sailing Ship* to Grand Prince Nikolai Pavlovich, whose great-grandson Nicholas II would be the last czar of all the Russias.

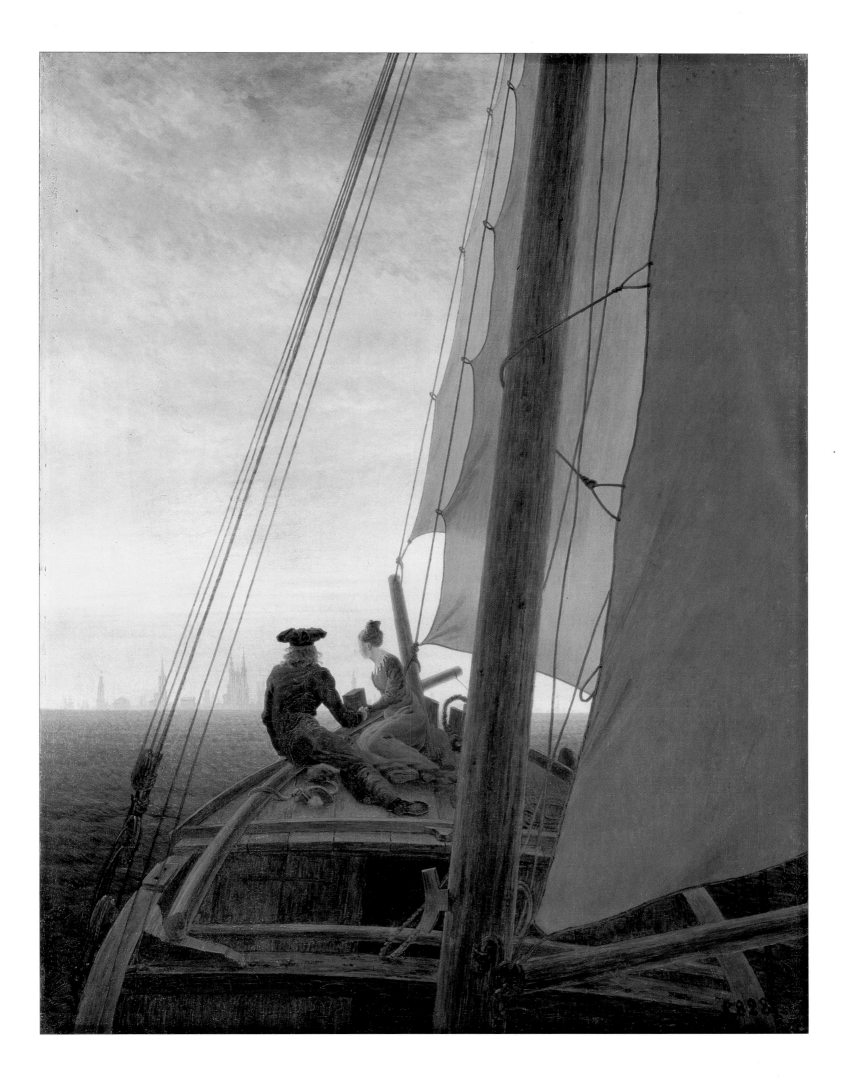

FORD MADOX BROWN

The Last of England

1852–1855

OIL ON PANEL, 32½" × 29½" (82.5 × 74.9CM). CITY MUSEUM AND ART GALLERY, BIRMINGHAM, ENGLAND.

*For better or for worse…*how many couples have faced an uncertain future together, their only security the household of their united hearts? Throughout history, people have left their homelands by choice, chance, or violence; if they were fortunate, it was with partners, families, or friends. Ford Madox Brown (1821–1893) used a very finished style—at first glance, an unemotional, "realistic" technique—to depict this couple's leave-taking. Yet the highly finished work emphasizes the emotions through an understatement that obliges us to look all the more closely, revealing the disdain in the face and gesture of the uniformed man, the uncertain posture of the couple, and the relationship between the two. In the politically tumultuous year 1848, Brown, not yet thirty years old, took on the much-discussed Dante Gabriel Rossetti (1828–1882) as a pupil, and was numbered among the Pre-Raphaelites, sharing their emphasis on subtle colors. Established though he was (albeit among fashionable, artistic "outlaws"), in this and other works, Brown demonstrated his sympathy for the forsaken; familiar with northern England, he might have watched the ships sailing from Liverpool, the English port that witnessed centuries of emigration.

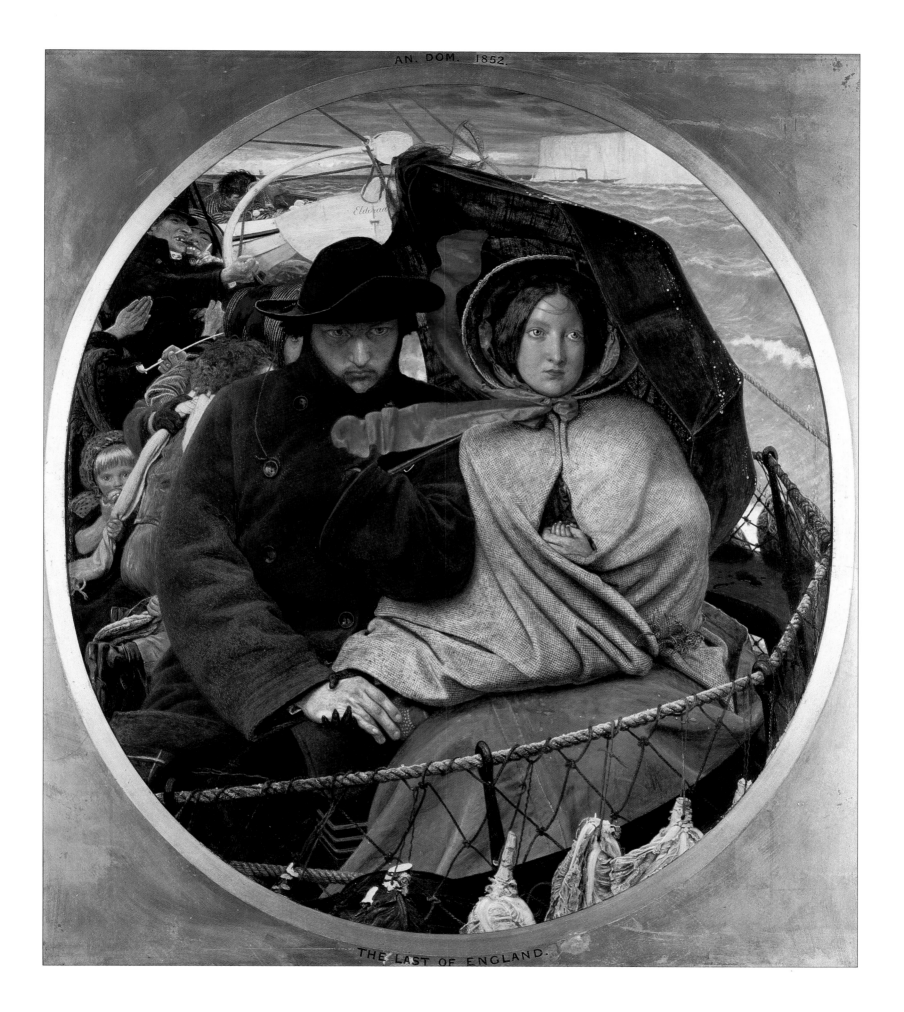

ADOLPHE-WILLIAM BOUGUEREAU

The Proposal

1872

OIL ON CANVAS, 64⅜" × 44" (163.5 × 111.8CM). THE METROPOLITAN MUSEUM OF ART, NEW YORK CITY.

In this scene, the principal clue to the maiden's feelings is the soft light that shines on her brow and upper body. Since she is indoors, the light can only be heaven-sent, revealing the feelings in her heart that modesty forbids her to speak aloud. The column outside her window, the lovers' costumes, and the design on the stone seat refer wistfully, if vaguely, to the late Middle Ages and early Renaissance, when the ideal of pure, courtly love still held sway in the arts. It was a period that connoted spirituality to a clamorous, material age of science and industry. Bouguereau (1825–1905) was renowned for his religious and allegorical paintings—qualities that suffuse *The Proposal*. Here, the artist has successfully cast this young woman, with her solemnity, her "woman's work," and her cat, as that late-Victorian ideal, the angel of the hearth. Despite Bouguereau's adherence to the social, thematic, and artistic standards of his time, in his own love life he had the courage to break with tradition—in 1896 he married the painter Elizabeth Jane Gardner, who in 1889 became the first American woman to win the gold medal at the Paris Salon.

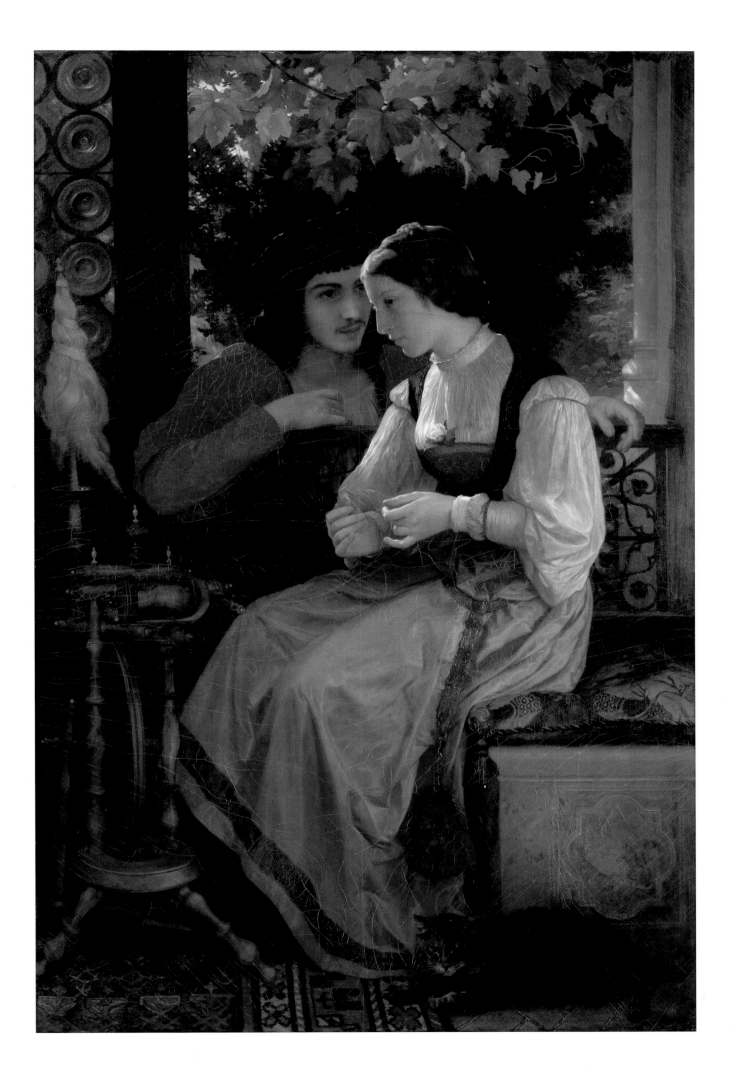

Jean-Léon Gérôme

Pygmalion and Galatea

c. 1890

Oil on canvas, 35" × 27" (88.9 × 68.6cm). The Metropolitan Museum of Art, New York City.

Pygmalion was a sculptor who hated all women. Yet the statue to which he dedicated his greatest effort was of a woman, and so perfect was his achievement that he lost his heart to it. Venus not only answered the desperate lover's prayer, transforming his creation into a living woman, but also attended the nuptials. Ovid's tale has resonated down through the centuries, speaking to private dreams. Gérôme (1824–1904), who taught Odilon Redon and Thomas Eakins, among others, was himself a sculptor, as well as a painter particularly extolled for the finished quality of his work. He was also known for the erotic content of his images, and in this work, these three attributes meet in a sculptural tour de force, in which we can trace Galatea's metamorphosis in the gradual warming of the skin tones from marble-white to creamy, lady-pale flesh. The masks on the shelf to the right refer to Greek tragedy, but Cupid, too, has undergone a change—from Eros, disturber of private and public peace, to this cloudborne, smiling angel.

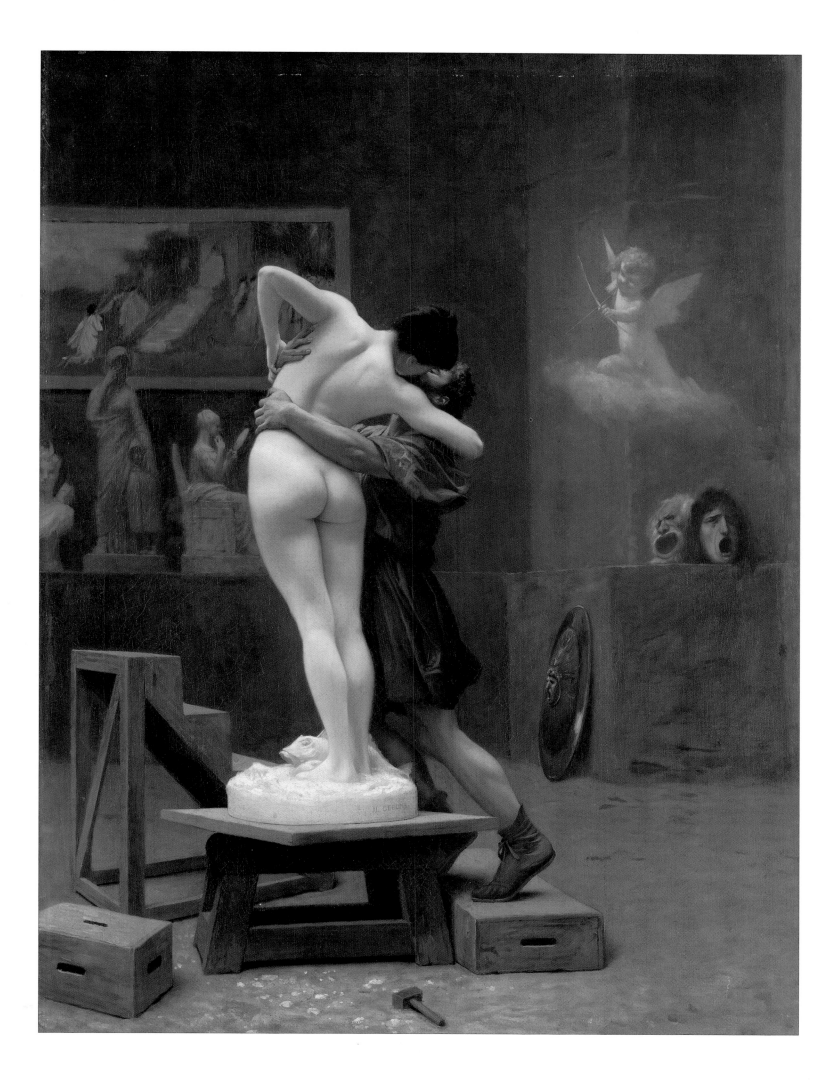

GUSTAV KLIMT

The Kiss

1907–1908

OIL ON CANVAS, 70⅞" (180CM) SQUARE. ÖSTERREICHISCHE GALERIE, VIENNA.

Gustav Klimt (1862–1918), son of a goldsmith, became an experienced professional decorative artist before

he was twenty; working in that field, he developed an extraordinary facility with the historical styles so popular at the

time. It was fitting, therefore, that in 1897 Klimt should have been elected the first president of the Vienna Secession,

a school of painting known for its highly decorative style. He subsequently absorbed some of the sinuous elaborations

of "decadent" artists such as Aubrey Beardsley (1872–1898) in England, and his themes were profoundly influenced by

the intertwined eroticism and spirituality of the fin de siècle European Symbolists. In *The Kiss*, the opulence of gold and

color suggests the brilliance of Byzantine church mosaics, while in its asymmetry the work refers farther back, to an

unspecified time characterized by primitive splendor and archetypically powerful, unmediated emotion. *The Kiss* shows

two people yielding sensuously to the desire that overwhelms them—but, like Klimt's audience, we can also feel in the

painting an allegory of the soul's hunger to transcend itself, to surrender to the infinite.

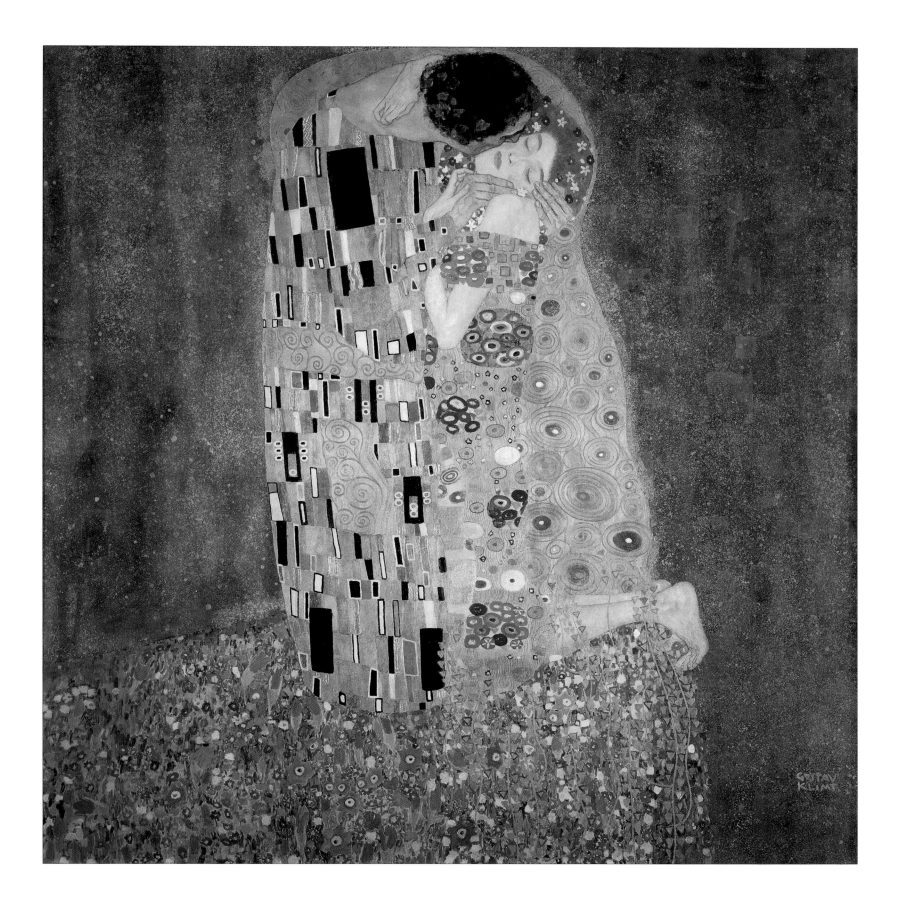

OSKAR KOKOSCHKA

Hans Tietze and Erica Tietze-Conrat

1909

OIL ON CANVAS, 30⅛" × 53⅝" (76.5 × 135.2CM). THE MUSEUM OF MODERN ART, NEW YORK CITY.

The Austrian descendant of Prague goldsmiths, Oskar Kokoschka (1886–1980) received no formal artistic training, and this may account for the immediate, unfiltered feeling of his Expressionism. In addition to being a painter and lithographer, Kokoschka wrote plays and poetry, and designed tapestries for interiors as well as scenery and costumes for the theater. Yet this active, creative artist shared the anxiety of turn-of-the-century Vienna, a time when nervous energy was often viewed as the natural manifestation—and therefore validation—of "superior" intelligence, sensitivity, and breeding. Kokoschka's portraits are of the aristocracy and the educated classes, the same environment that produced Sigmund Freud, whose Vienna Psycho-Analytical Society was officially formed in 1908, the year before Kokoschka painted this double portrait. Hans Tietze and Erica Tietze-Conrat were art historians, and the painter has described vibrant auras emanating from each and from both together. By rubbing and scraping the painted surface, Kokoschka sought to convey the electric, almost erotic quality of this brilliant couple's fervent intellectual and emotional discourse.

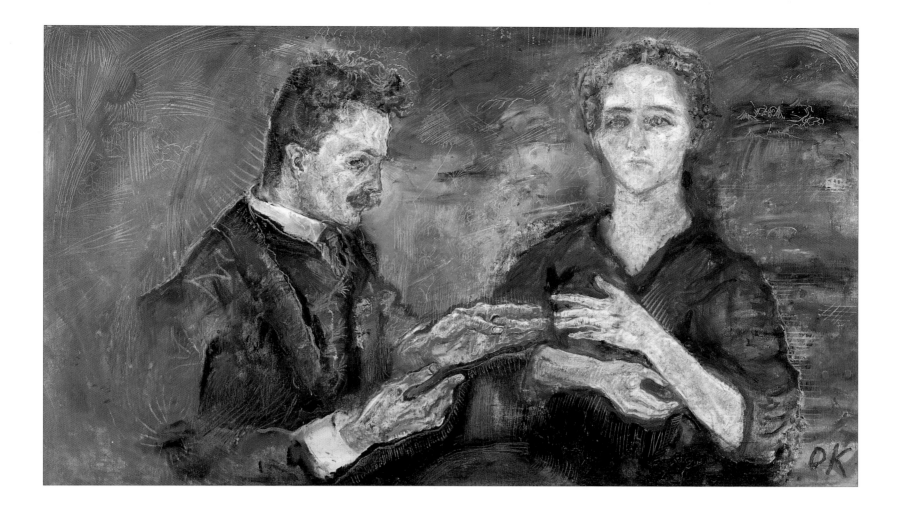

WASSILY KANDINSKY

Improvisation Number 27: The Garden of Love

1912

OIL ON CANVAS, 47⅜" × 55¼" (120.3 × 140.3CM). THE METROPOLITAN MUSEUM OF ART, NEW YORK CITY.

Kandinsky (1866–1944) painted *The Garden of Love* in 1912, two years after he finished the work generally considered to be the first entirely abstract painting, *First Abstract Watercolor*. Part of the pleasure of this picture derives precisely from Kandinsky's hide-and-seek play with abstraction. Does the green shape at the top center of the painting depict a loving couple stretched out in the title garden? Two lines echo the angle of the green shape, emphasizing it. The first is a wavy brown stroke halfway down the right side, the second the outline of the white shape at lower right. On the left, a stone gray rectangle is crossed by an armlike shape that suggests an embrace. The garden of love is a theme common to all cultures that observe a cult of romantic love, and conveys the exclusiveness of passion, a world reduced to two. The bright colors, too, are found in nature, even in a garden. Yet the whole is an exhilarating divertissement, a trick inspired by the viewer's—and the painter's—experience, translated through the artist's enthusiasm for the infinite possibilities of abstraction.

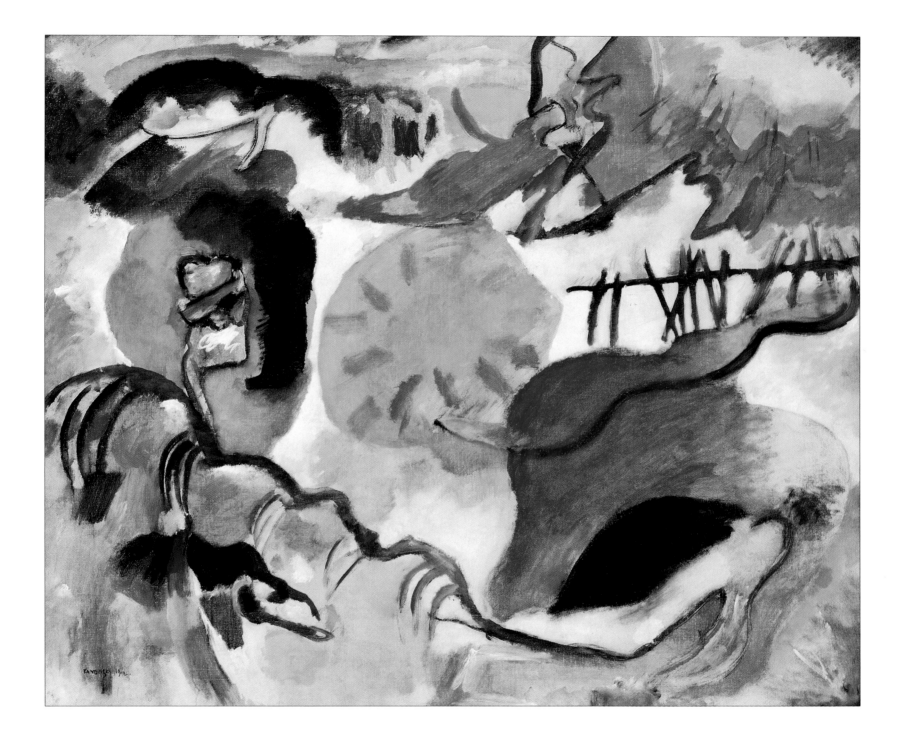

MARC CHAGALL

Birthday

1915

OIL ON CARBOARD, 31¾" × 39¼" (80.6 × 99.7CM). THE MUSEUM OF MODERN ART, NEW YORK CITY.

*M*arc Chagall (1887–1985) was born in Vitebsk, Russia, and studied painting at the Imperial School of Fine Arts in Saint Petersburg. He went to Paris, where he absorbed the various popular styles of that ebullient period, integrating them into an entirely original "naive" idiom that refers as readily to Russian village life and to Jewish traditions and mysticism as to Fauvism, Cubism, and Surrealism. After the revolution, Chagall returned to Russia, becoming district commissar for fine art; in 1922, he went to Berlin, then once again to Paris, where he settled after living in the United States during World War II. In this work, the artist is (literally) head over heels in love—it is his birthday, and his dear Bella Rosenfeld has agreed to marry him. Together, their bodies almost form a circle, like a wedding ring seen from the side. In the upper right corner of the window on the left is a small tribute to Cubism, as in the perspective of the table and the tabouret. But where the Cubists abstracted reality, Chagall affectionately treasures it, from the cake on the table to Bella's bouquet, which, like the painting itself, is an exuberant expression of the artist's enduring love.

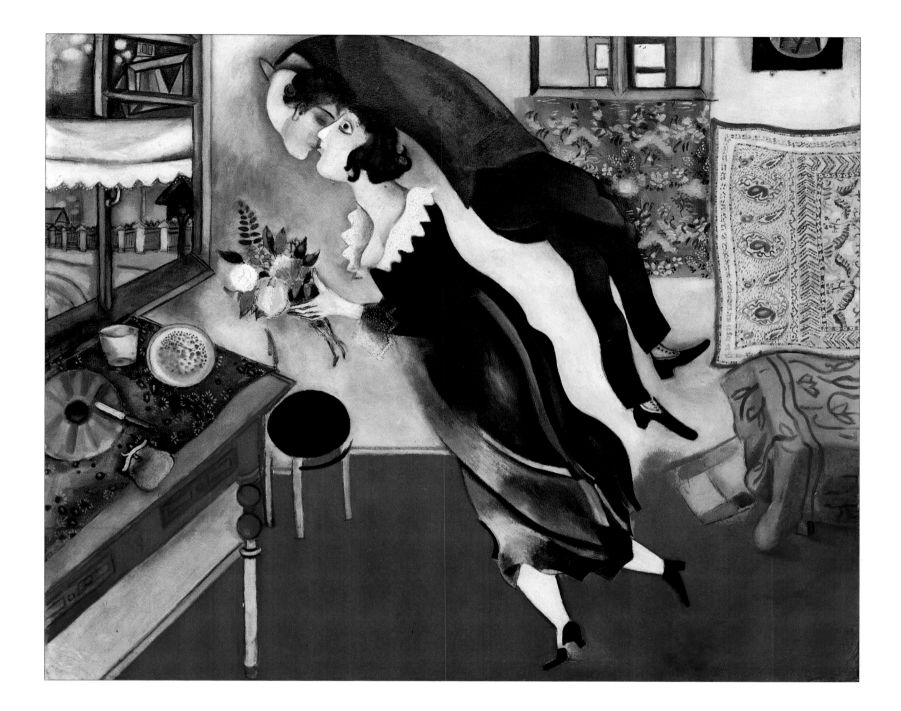

PABLO PICASSO

The Lovers

1923

Oil on linen, 51¼ × 38¼" (130 × 97.2cm). National Gallery of Art, Washington, D.C.

The first quality that may strike the viewer is the complex tenderness of this painting. Some of this effect derives from a balance of delicate and bold colors—these are not the hues of polite society. Indeed, the young man's outfit recalls those of Picasso's circus performers, his *saltimbanques*. The lover stands straight and reliable, looking at his beloved. Her posture is as feminine as his is masculine, but she is the focus of the artist's gaze as much as of her sweetheart's: her face and body are more attentively constructed, almost sculpted, the draped fabric revealing the hidden contours that so intrigued Picasso (1881–1973). The mystery of sex, of what was to him the "otherness" of women, drew him through-out a lifetime to explore their physicality and his own obsession, in a search that could have no resolution. Characteristic of Picasso's female figures are fleshy, powerful forearms. Here, they are the plump, healthy arms of a young woman, but the way they and the suggested thigh are modeled recalls, for example, the artist's *Two Nudes* (1906). Related to Picasso's circus performers, these young people share some of their romantic aura. Unattached to the "normal," bourgeois world, they rely even more upon each other. Depending upon their youth and strength, their attachment to the present is all the more poignant, suggesting, perhaps, the eternally poised moment of love.

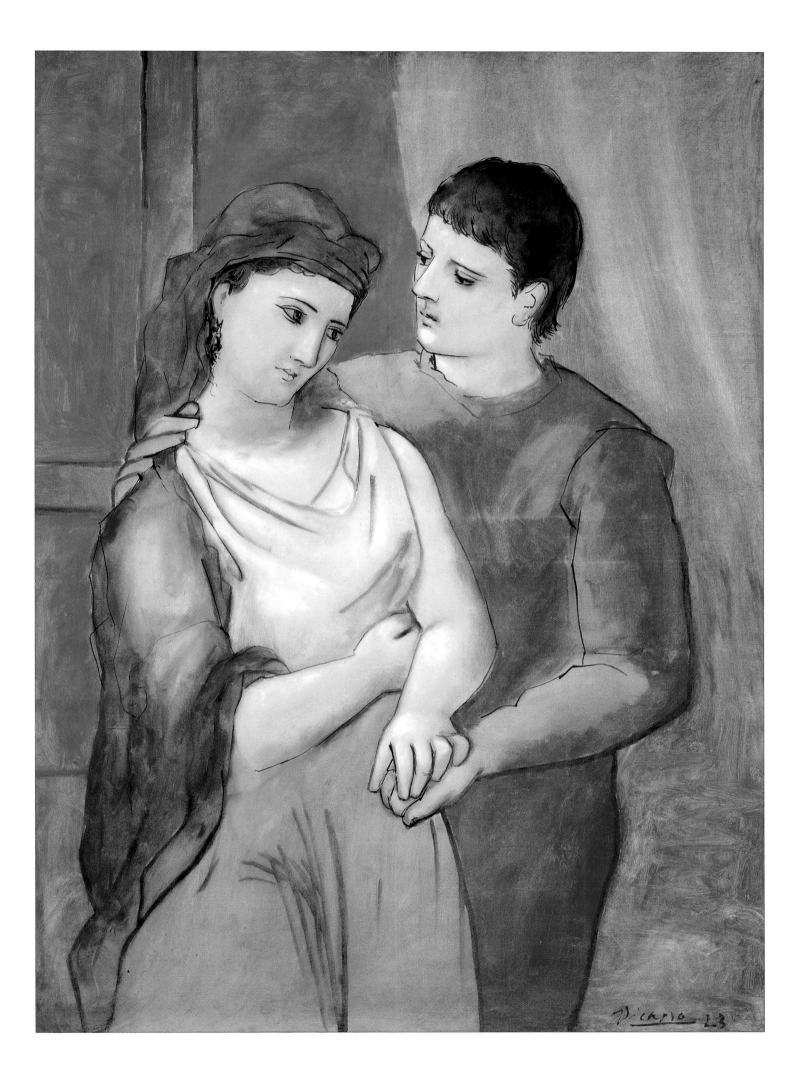

PALMER HAYDEN

The Janitor Who Paints

1939–1940

OIL ON CANVAS, 39⅛" × 33" (99.3 × 83.8CM).
THE NATIONAL MUSEUM OF AMERICAN ART, SMITHSONIAN INSTITUTION, WASHINGTON, D.C.

The way in which this portrait of a painter at work breaks with tradition tells us a great deal about what Palmer Hayden (c. 1890–1973) was bringing to the work. Gone is all sentimental romance about the "starving artist"; in its place are a number of strong emotional statements. One is that we can help the people we love achieve their dreams— here, even the cat does its part, as the portrait on the far wall attests. At the same time, there is anger in the energy with which the garbage can is thrust into the foreground, wreaking havoc with the perspective, almost interfering, in a surrealist touch, with the painter's movement. The sarcasm of the title, too, conveys Hayden's frustration on his own and others' behalf: this is a painter who works as a janitor to support himself and his family—not a janitor with a quirky hobby. X rays of this painting revealed a controversial occasional characteristic of Hayden's style: the original figures were grotesque caricatures. Here, though the man and baby are still expressively rough, the woman's fond beauty provides the keynotes of confidence and devotion that make this a painting about love.

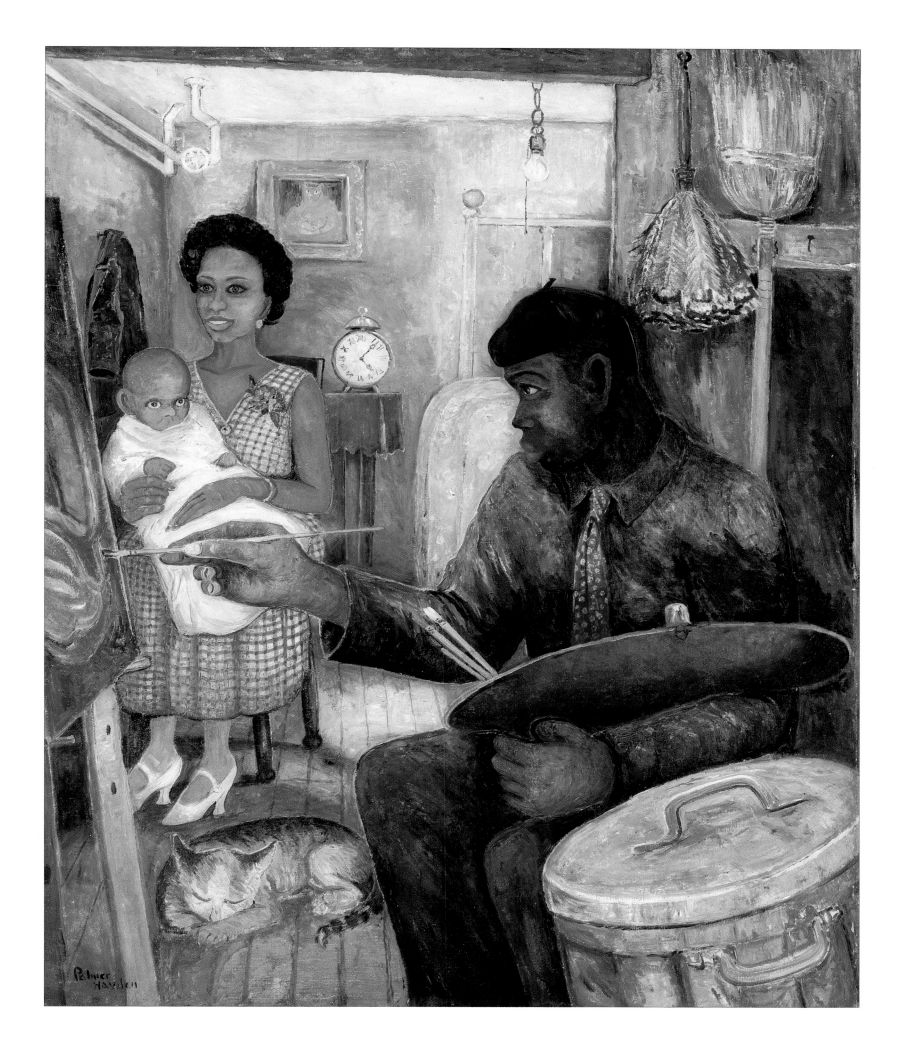

FRIDA KAHLO

Self-Portrait with Diego on My Mind

1943

OIL ON CANVAS, 29⅞" × 24" (76 × 61CM). JACQUES AND NATASHA GELMAN COLLECTION, MEXICO CITY.

Her head is at the angle that characterizes her many self-portraits, but Frida Kahlo (1907–1954) looks contemplatively to the left, instead of meeting the viewer's gaze, as elsewhere. The image of Diego Rivera, the Mexican muralist to whom Kahlo was twice married, surmounts her brow, but also travels her intelligence and her senses through the nerves that stretch visibly out into the invisible world. It is her expression of this super-consciousness, this deliberately composed depiction of the most intense private emotion, that endows the artist's work with its singular irony and power, and inspired André Breton (1896–1966) to praise Kahlo as an important Surrealist—an identification she rejected. Yet even as she presents us with an unapologetic portrait of obsession—a self-portrait that is, at the same time, a double portrait—the artist is exploring, equally passionately, other aspects of herself. Like a number of her fellow artists in Mexico City, Kahlo was dedicated to the cultural and political movement of *Mexicanidad*; as the daughter of a Hungarian Jewish immigrant and a *mestiza*, "Mexicanness" had a personal meaning as well, one that appears in most of her work. Here, she wears a traditional wedding dress, expressing, in part, her and Rivera's "marriage of true minds." But the effect is far from bridal, for the white filaments, too, reach out into the universe.

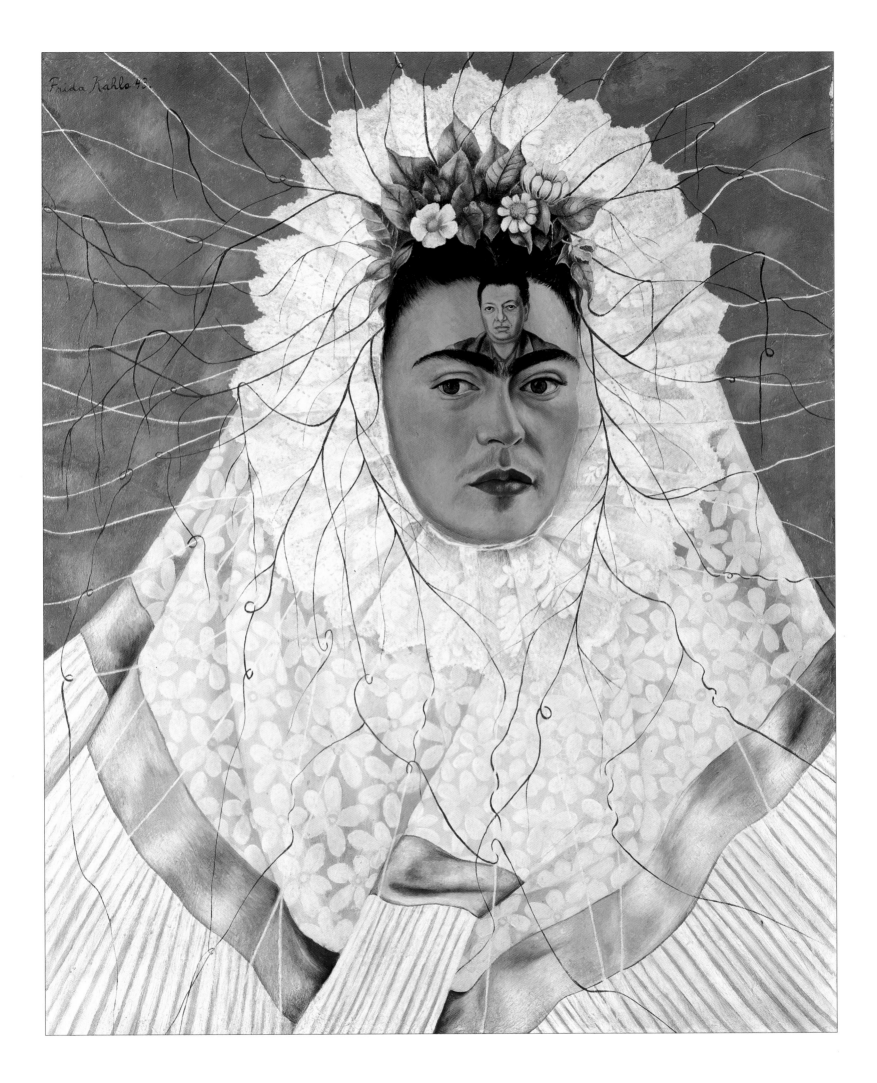

WILLIAM HENRY JOHNSON

Mom and Dad

1944

OIL ON PAPERBOARD, 31" × 25⅜" (78.7 × 64.4CM).
NATIONAL MUSEUM OF AMERICAN ART, SMITHSONIAN INSTITUTION, WASHINGTON, D.C.

Raised in Florence, South Carolina, William Henry Johnson (1901–1970) studied at the conservative School of the National Academy of Design in New York City. He subsequently lived abroad, in Paris and then Denmark; thus he is still little-known in his country of birth. In this neoprimitive double portrait, the dramatic difference in the ages of husband and wife tells a poignant tale of a vital husband (and father) lost young, and a long widowhood. Yet Henry Johnson's cheerful smile is reflected in Alice Johnson's contented countenance. Alice is an elegant older woman, her outfit a sophisticated combination of patterns—perhaps a compliment from her artist son. Here, though lighter-skinned than in Johnson's *Mom Alice*, a portrait of her alone, she is darker than Henry. William Johnson was the lightest-skinned of his family; the artist internalized this difference, significant in a racially conscious nation, and sometimes expressed it in a marked attention to skin color. (It may be a wry comment on his part that even the cats are brown and white.) Still, for all its apparent openness, this tribute to marital and familial love acknowledges the enigma at the heart of a union, a mystery that no outsider—not even the most affectionate son—can know.

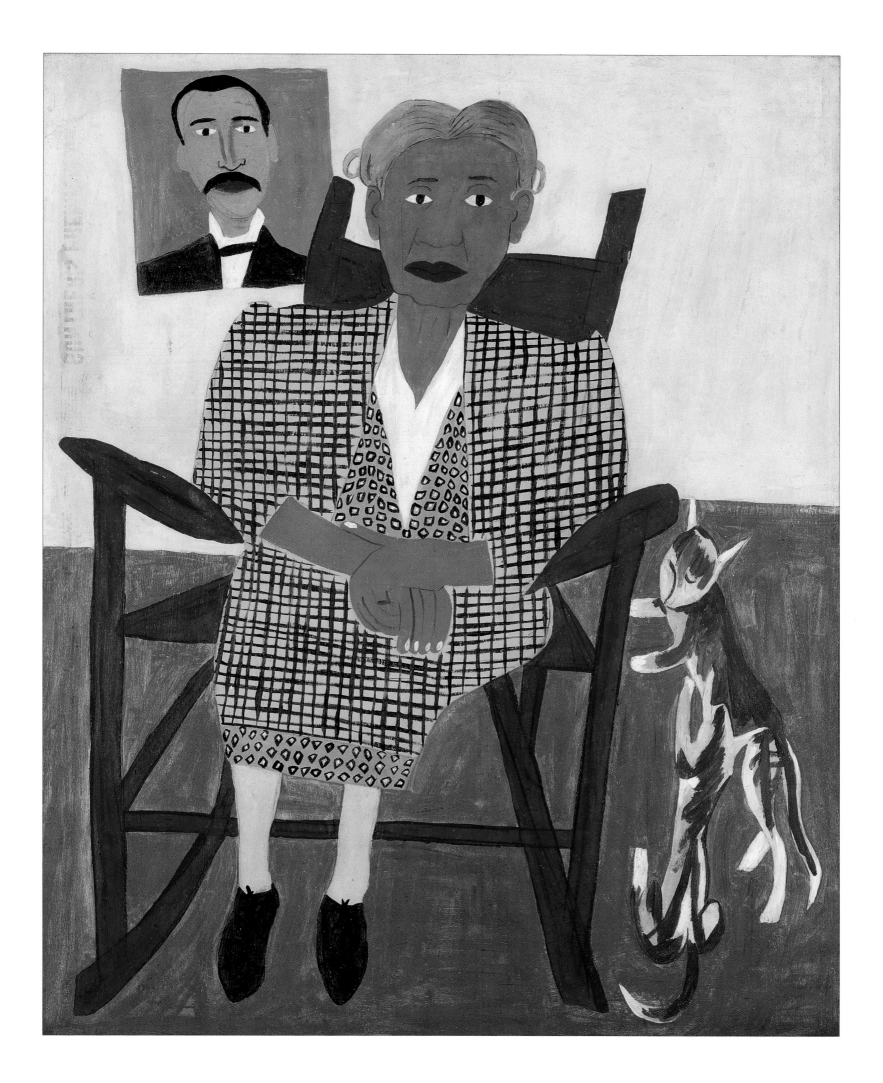

CHARLES ALSTON

Family

1955

OIL ON CANVAS, 48¼" × 35¾" (122.6 × 90.8CM). COLLECTION OF WHITNEY MUSEUM OF AMERICAN ART, NEW YORK.

Charles Alston (1907–1977) received his artistic training at Columbia University in New York City, and went on to teach at the City University of New York and the Art Students' League. Like other artists, then as now, Alston refused to censor aspects of the African-American experience in favor of a more conventionally "acceptable" image, choosing instead to apply his elegant and expressive figurative Cubist style to inclusive, accurate portrayals. For example, the walls of the room are made of boards; the floor may be pounded earth; the woman is barefoot; and the husband is wearing a T-shirt. With a balance of warm and cool colors, Alston emphasizes the harmony that flows from the deep, mutual affection of this handsome couple. He has placed the mother in the foreground to emphasize the respect in which the family holds her. The children's postures and the ease with which one of the little girls turns in toward her family tell of the self-reliance and intimacy that the parents have instilled in their children. These are country people of modest means, but wealthy beyond measure in love.

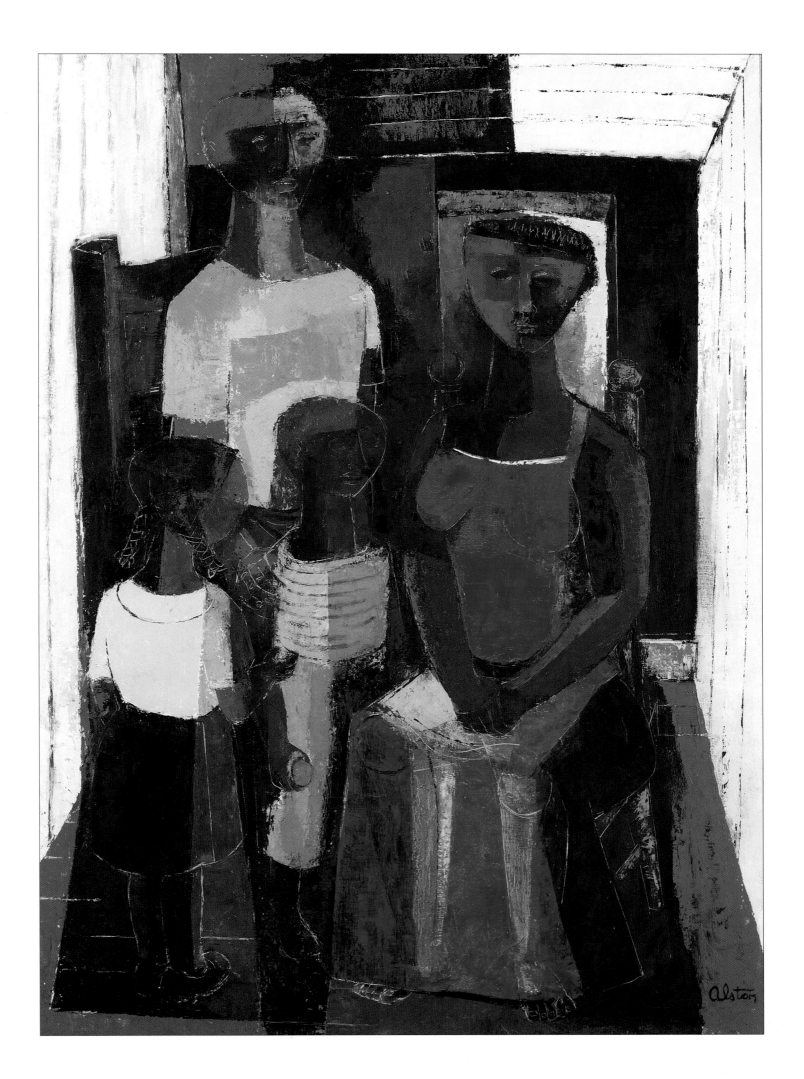

ROY LICHTENSTEIN

Drowning Girl

1963

OIL AND SYNTHETIC POLYMER PAINT ON CANVAS, 67⅝" × 66¾" (171.6 × 169.5CM).
THE MUSEUM OF MODERN ART, NEW YORK CITY.

In the early 1960s, Roy Lichtenstein (b. 1923) made art derived from—and therefore, to some degree, about—mass-produced objects. These "reproductions" became icons of pop art, which brought to the surface of the art world the artifacts of everyday life that it had often scorned. Lichtenstein turned to true-romance comics to produce this rich work that causes viewers to smile with recognition. The signs of the emotional state of the "girl" are far different from the stylized drops that conventionally indicate restrained distress. Instead, her welling tears look like the waves engulfing her—waves taken from Japanese prints. Thus, Lichtenstein has painted a unique work that refers not only to American commercial publishing, but to a fine-art process—printing—that, albeit on a much smaller scale, also results in multiples. Though some pop artists wanted to "expose" the "banality" of American culture, this image recalls an adage of the Argentinian author Jorge Luis Borges (1899–1986), who wrote: "Worn images are often closest to the truth." What person in love has not, for a moment at least, experienced a surge of stubborn, irrational passion such as this?

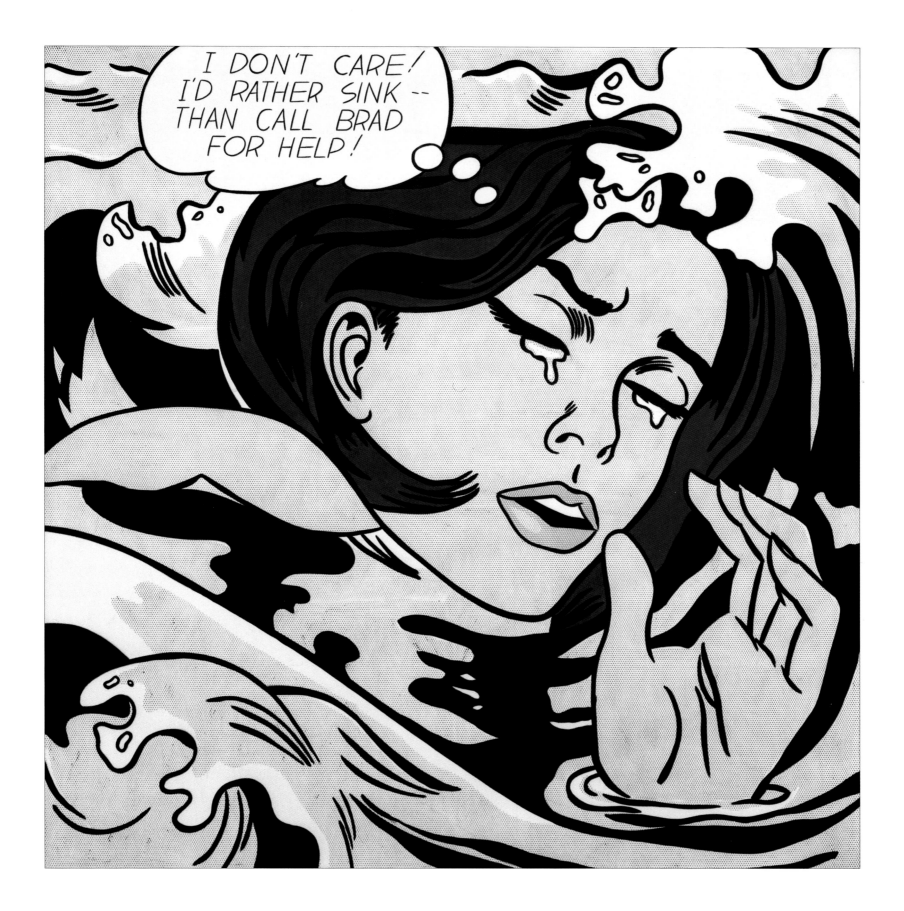

ROMARE BEARDEN

Allegheny Morning Sky

1978

COLLAGE, 10⅛" × 14½" (25.3 × 36.2CM). COLLECTION OF MR. AND MRS. GUTNER, NORTH WOODMERE, NEW YORK.

If we knew only the title of this work, we might imagine a landscape or other nature study, rather than a dark, early-morning workday sky lit by the flames of industrial chimneys. Yet kindness and poetry are present in the drowsy quiet of a couple's routine, a rhythm that the artist has emphasized with the calendar on the wall. The woman has risen even earlier than her husband in order to prepare his breakfast and lunch, a practical cherishing he will take with him throughout his working day. We see the tenor of her workdays as well, in this well-tended, well-decorated home, harmonious despite the unmatched pieces, just as the jagged edges of the collage elements manage to portray the rounded corners of this loving pair. Romare Bearden (1911–1988), whose mother ran the New York office of the *Chicago Defender*, an African-American newspaper, grew up at the heart of the Harlem Renaissance. Influenced by Cubism, he experimented with various styles, searching for a technique that would express his feelings about his heritage. Like the Social Realists he admired, especially the Mexican artists Rufino Tamayo and José Clemente Orozco, Bearden sought to depict the heroes of daily life. This modest couple are two such heroes.

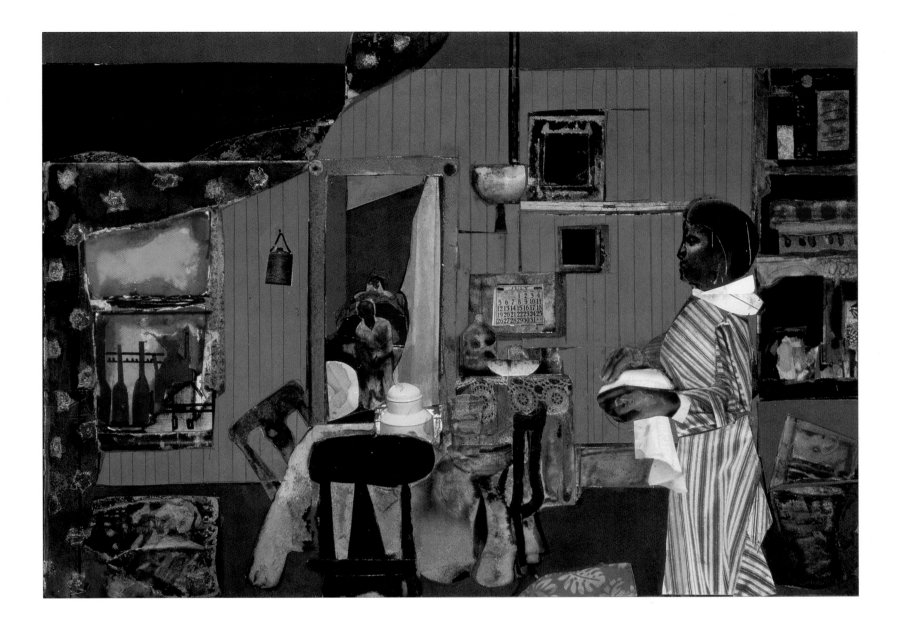

PHOTOGRAPHY CREDITS